IMAGES
of Aviation

MARYLAND AVIATION

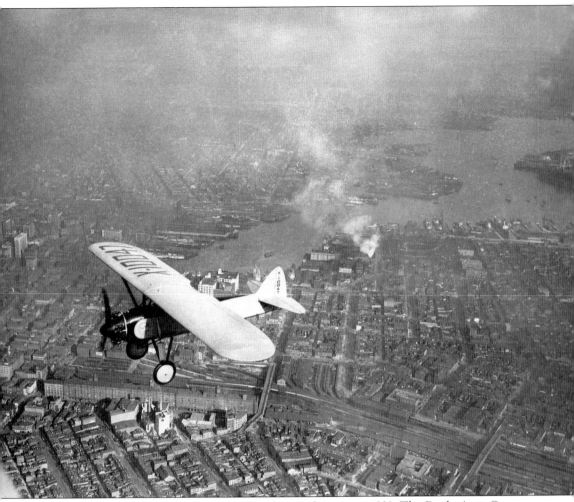

A Doyle O-2 Oriole flies over Camden Yards in Baltimore in 1929. The Doyle Aero Company of Elm Street in Hamden was one of the offshoots of the Lindbergh boom in Maryland aviation during the late 1920s. (Maryland Historical Society, Baltimore.)

ON THE COVER: "Old Number 9" was the ninth of 5,266 B-26 Marauder medium bombers built by the Glenn L. Martin Aircraft Company of Middle River. This particular Marauder flew combat missions in the Aleutians early in World War II. In May 1943, it returned to Maryland and was placed on display in downtown Baltimore between the War Memorial (pictured) and Baltimore City Hall. (Glenn L. Martin Maryland Aviation Museum, Middle River.)

IMAGES
of Aviation

MARYLAND
AVIATION

John R. Breihan

ARCADIA
PUBLISHING

Published by Arcadia Publishing
Charleston SC, Chicago IL, Portsmouth NH, San Francisco CA

Printed in the United States of America

Library of Congress Catalog Card Number: 2008930387

For all general information contact Arcadia Publishing at:
Telephone 843-853-2070
Fax 843-853-0044
E-mail sales@arcadiapublishing.com
For customer service and orders:
Toll-Free 1-888-313-2665

Visit us on the Internet at www.arcadiapublishing.com

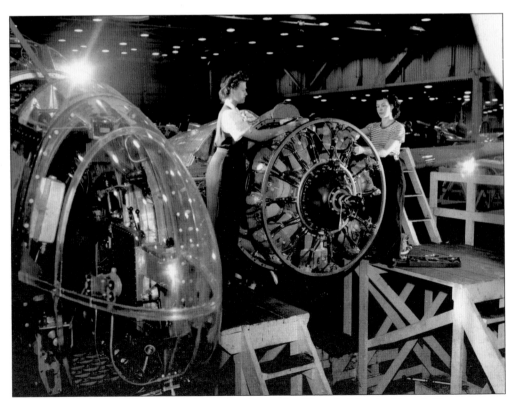

Women work to complete a Baltimore light bomber in the Glenn L. Martin Aircraft Company near the city of that name, 1943. (Glenn L. Martin Maryland Aviation Museum, Middle River.)

CONTENTS

ACKNOWLEDGMENTS

I have many people to thank for helping me assemble all these photographs, in particular Stan Piet of the Glenn L. Martin Maryland Aviation Museum, an incomparable photographer and archivist. Besides sharing with me the photo archives of Maryland Aviation Administration (MAA), Ashish Solanki personally took most of the photographs attributed to the MAA. I am also greatly indebted to Kurtis Meyers and Kent A. Mitchell of the Hagerstown Aviation Museum, Roger Mason and Harry Mettee of the Glenn L. Martin Maryland Aviation Museum, Cathy Allen of the College Park Aviation Museum, Tom Quinlan of the Patuxent River Naval Air Museum, Dr. Joseph Rainer and Chrystal Maynard of the U.S. Army Ordnance Museum, James Foard and Charles S. Kohler of the Maryland Air National Guard, and Ned Preston, Barry A. Lanman, Richard Hughes, and Nicole Diehlmann of the Maryland Historical Trust's 2003 volume, *Maryland Aloft*. A hearty thanks as well to all the other archives where I was helped to find and granted permission to publish these historic photographs.

Photograph sources and abbreviations:

AACHS	Ann Arundel County Historical Society
AOM	U.S. Army Ordnance Museum, Aberdeen
BAL	Barry A. Lanman
EPFL	Enoch Pratt Free Library, Central Branch, Baltimore
CPAM	College Park Air Museum
DO	Dave Ostrowski
DPNHS	Dundalk Patapsco Neck Historical Society
GLMMAM	Glenn L. Martin Maryland Aviation Museum, Middle River
HAM	Hagerstown Aviation Museum
MANG	Maryland Air National Guard
MAA	Maryland Aviation Administration
MdHS	Maryland Historical Society, Baltimore
MHT	Maryland Historical Trust, Crownsville
NASM	National Air and Space Museum
PRNAM	Patuxent River Naval Air Museum
UMCP	*Baltimore News-American* (Hearst) Collection, Hornbake Library, University of Maryland, College Park
WCHS	Washington County Historical Society, Hagerstown

INTRODUCTION

Edward Warren of Baltimore was the first American to leave the earth's surface by artificial means when he ventured aloft in Peter Carnes's hot-air balloon in 1784. In the two and a quarter centuries since then, Marylanders have designed and built thousands of aircraft. They have leveled Maryland's green fields to build airports large and small, including the world's first. The Free State has been the site of pioneering efforts in aircraft speed, airmail, instrument flying, commercial air travel, and private flying.

Three events dominate the history of aviation in Maryland. The first occurred in 1909, when U.S. Army lieutenant Frank Lahm, flying in a balloon, identified a level field of 160 acres near a rail line to Washington as an ideal place for military pilots to learn to operate the army's new flying machine. By the terms of a contract just signed, the machine's inventors and builders, Orville and Wilbur Wright of Dayton, Ohio, were to do the training. The site chosen was in College Park, not far from Maryland's state university. Once the government had leased the field, Wilbur Wright duly arrived to conduct classes for Lieutenants Lahm, Frederick E. Humphries, and Benjamin Foulois. Wright also took aloft Sarah Van Deman, the first woman to fly in an airplane in the United States. Flight operations of all types, both military and civilian, have taken place at College Park ever since October 1909, making it the world's oldest airport in continuous use.

The second event came in October 1927, when Charles A. Lindbergh landed at Baltimore's Logan Field in the *Spirit of St. Louis*—the same airplane he had flown from New York to Paris four months earlier. In a single day, the young flyer galvanized local efforts to build an aviation industry in Maryland. New aircraft factories and airports sprang up; most even survived the Great Depression that began two years later. By the time of the third of these events, World War II, tens of thousands of Marylanders and migrants from across the country were at work designing, building, and testing airplanes. More still built and operated airports. They changed the face of Maryland's economy and communities from 1939 to 1945.

Since World War II, the aircraft manufacturing industry has declined in Maryland, but other aviation-related industries have boomed, from radar and electronics to various forms of air travel. No longer is it a novelty to hear an aircraft pass overhead. But, even so, we look up to marvel at the freedom and grace of traveling through the arching sky.

I had to leave a lot out in assembling this book. Many colorful people are missing: the overweight balloonist Peter Carnes; test pilots Pat Tibbs and Ken Ebell; aerial promoters and "flying family" the Hutchinsons; biplane pilot Gus McLeod; executives "Fuzz" Furman, William Hartson, Peyton Magruder, and Norman Augustine; Tuskegee airman and businessman Raymond Haysbert; and many others. For reasons of space, I left out aviation equipment manufacturers, from Bendix Radio to Northrop Grumman, and I did not venture into the fields of aeronautical research or space exploration. What is left are airplanes in all their local varieties, the factories where they were built, and the airports from which they flew. For those who, like me, like to view and admire these sleek and clever machines in person, I have when possible indicated where they might be seen, either in Maryland or elsewhere in our region.

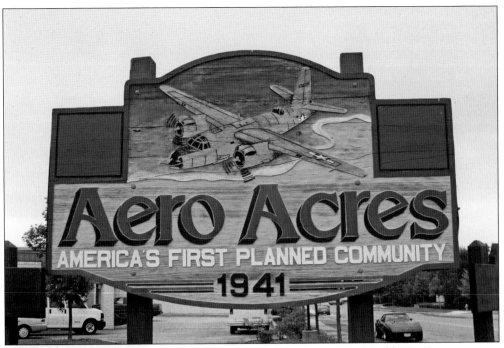

Maryland's immense World War II aviation industry gave rise to communities like Aero Acres in Baltimore County, with its streets named after aircraft parts or famous flyers. (Stan Piet.)

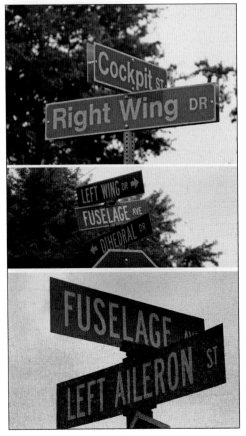

One

PIONEERS

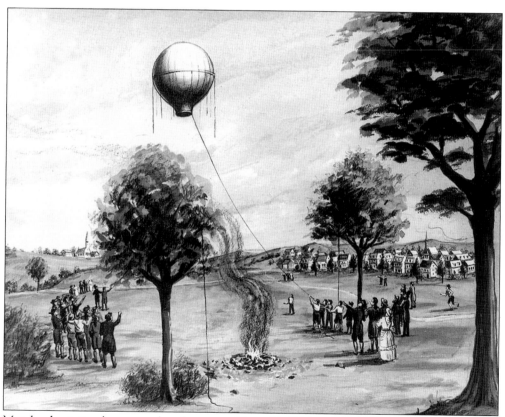

Maryland aviation began on the afternoon of June 24, 1784, in Howard Park, outside Baltimore. Peter Carnes of Bladensburg constructed a 30-foot hot-air balloon modeled on those tested by the Montgolfier brothers in France the year before. Carnes's "American Aerostatic Balloon" lacked the capacity to lift its 230-pound inventor, but a daring teenaged Baltimorean, Edward Warren, volunteered to become the first American "aeronaut." (NASM.)

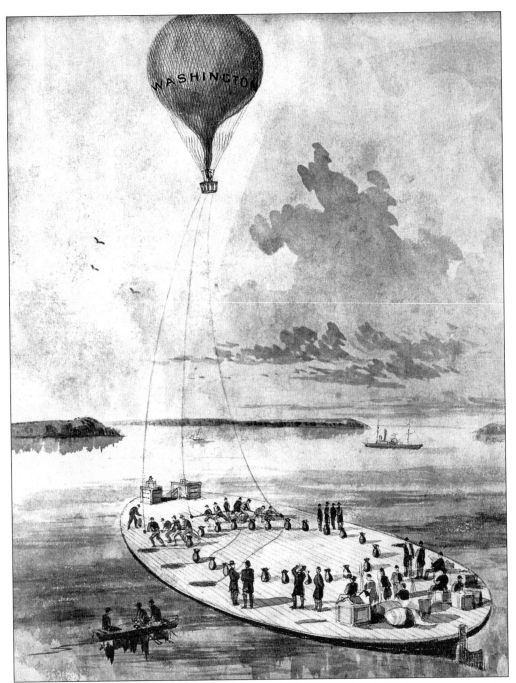

Early in the Civil War, Thaddeus Lowe organized a balloon corps for the Union army, promising that aerial observers would be able to scout the positions of Confederate troops. Nowhere was this more important than along the Potomac River separating Maryland from Virginia. Lowe converted a coal barge, the 122-foot *George Washington Parke Custis*, to serve as a mobile balloon base. A gas generator was installed to fill the balloons, and the deck was planked over for unobstructed landings. Completed in 1861, the *Custis* was in use for only a few months, but it does lay claim to having been the world's first aircraft carrier. (NASM.)

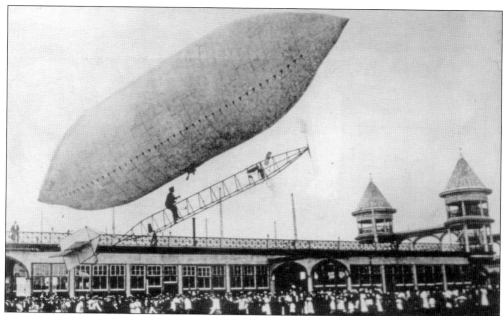

Balloons remained popular throughout the 19th century as carnival novelties. In June 1908, the daredevil aeronaut Lincoln Beachey performed with his dirigible at Baltimore's Electric Park amusement park. With the balloon powered by a backfiring motorcycle engine that threatened to ignite the hydrogen-filled gasbag, and Beachey trying to control the craft by running back and forth on the catwalk, the act produced equal parts comedy and terror. (EPFL.)

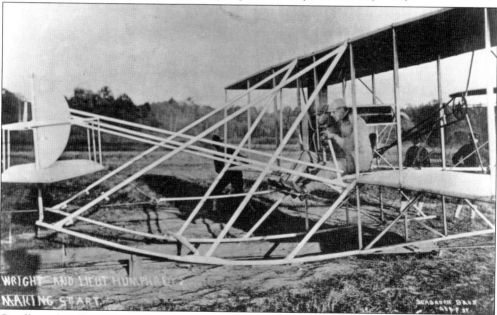

Orville and Wilbur Wright flew the first successful heavier-than-air craft at Kitty Hawk, North Carolina, in December 1903. After perfecting their flying machine over the next few years, they successfully demonstrated it to military authorities at Fort Myer, Virginia. Their army contract brought the Wrights to Maryland to establish the world's first flight school at College Park. Wilbur Wright personally trained the first army pilots. (CPAM.)

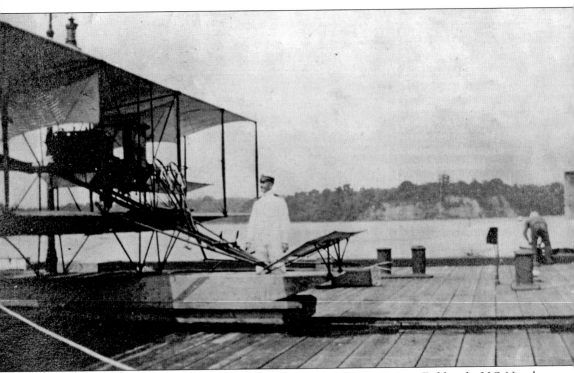

Flying a Wright biplane, navy lieutenant John Rogers took off from Farragut Field at the U.S. Naval Academy in Annapolis on September 7, 1911—the first naval aviation flight. The following July, Lt. Theodore G. Ellyson, shown here, made the navy's first attempt at a catapult-launched takeoff, also at Annapolis. Hopefully he was not wearing this dress uniform, as the Curtiss hydroplane pitched up after launch, stalled, and fell into the water. Ellyson was not seriously injured and finally made the first successful catapult launch later in 1912. This pioneer naval aviator was buried at the Naval Academy Chapel after his death in an air crash in 1928. (AACHS.)

The dapper young Charles Elvers, seen here in 1910, was the builder of Maryland's first airplane. He made his first flight on October 22, 1909, from a pasture on his father's farm in Owings Mills. (EPFL.)

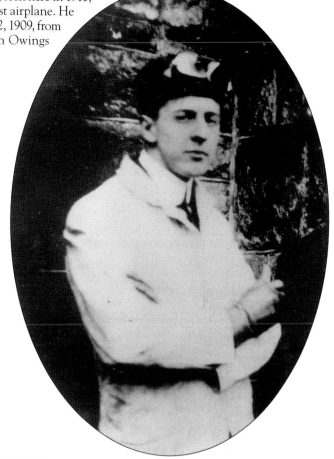

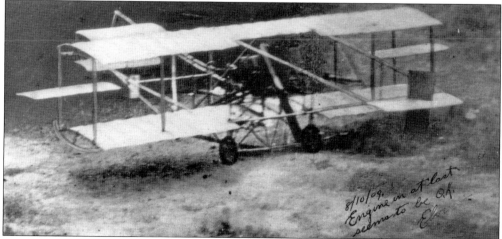

The Elvers plane obviously derived from aircraft designed by the Wright brothers' great rival, Glenn Curtiss. It was steered by means of ailerons mounted between the wings rather than the Wrights' technique of wing-warping. Elvers described it as a "maze of cloth-covered sticks, a confusion of wires, a forest of home-made gadgets." (EPFL.)

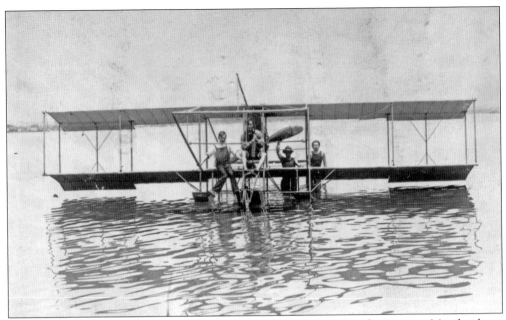

Another pioneer Maryland aircraft builder was Edward R. Brown, who established the Brown Aeronautical Company in 1910–1911. His first effort, christened the "Lord Baltimore," was destroyed in a fire in October 1910. Undaunted, Brown and two assistants built the "Lord Baltimore II" in 1911. An amphibian, it was first flown in Curtis Bay by the pioneer aviator Anthony Jannus. On its second flight, with Brown at the controls, it crashed. (EPFL.)

Anthony Jannus, born in Washington, D.C., made his first flights at College Park. After Brown's fiasco, he left Maryland in late 1911 to work for the Benoist Aircraft Company in St. Louis. In 1914, he was the pilot for the first commercial heavier-than-air scheduled airline service between Tampa and St. Petersburg, Florida. (EPFL.)

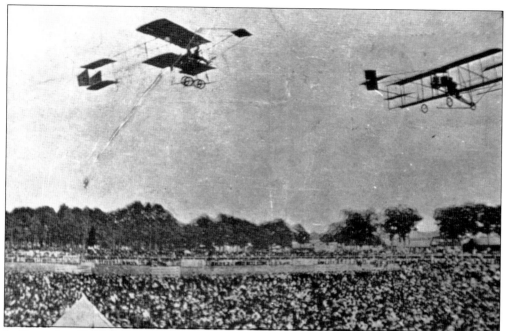

In November 1910, the Aero Club of Maryland sponsored a grand "air meet" at Halethorpe in Baltimore County. Aviators representing French and American manufacturers competed for $50,000 in prizes. Thousands of thrilled spectators watched from stands alongside a temporary airfield a mile long and 300 yards wide. In this composite photograph, a French Farman and an American Curtiss biplane are aloft at once. They probably performed separately. (BAL.)

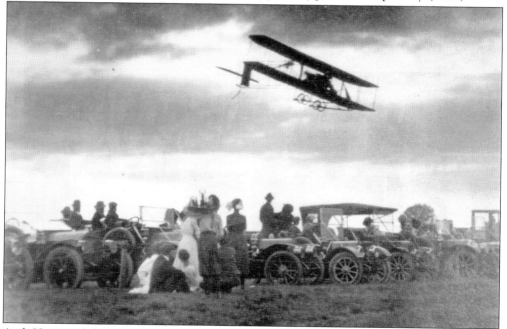

Arch Hoxsey of the Wright Exhibition Team flies over the edge of the Halethorpe grounds in a Wright Model B. Hoxsey was killed the following month attempting an altitude record at a Los Angeles air meet. (EPFL.)

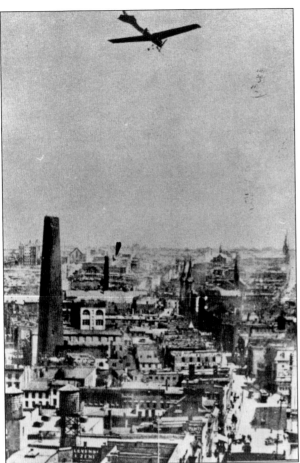

The most memorable event of the 1910 Aero Meet was a flight by the English aviator Hubert Latham over downtown Baltimore. Flying a French Antoinette monoplane, Latham followed a prescribed course of 22.5 miles that took him over the Phoenix Shot Tower, Fort McHenry, Patterson and Druid Hill Parks, the Winans Residence at 1217 St. Paul Street, and the Baltimore *Sun*, which offered a $5,000 prize for the flight. (AACHS.)

In 1920, the Washington inventor Emile Berliner and his son Henry began experimenting at College Park Airport with aircraft configured for vertical flight. In February 1924, the Berliner No. 5, adapted from a World War I French Nieuport, managed a controlled flight of 90 seconds, achieving an altitude of about 15 feet. Although others eventually perfected the helicopter, Henry Berliner was later a partner in two Maryland aircraft manufacturing companies. (CPAM.)

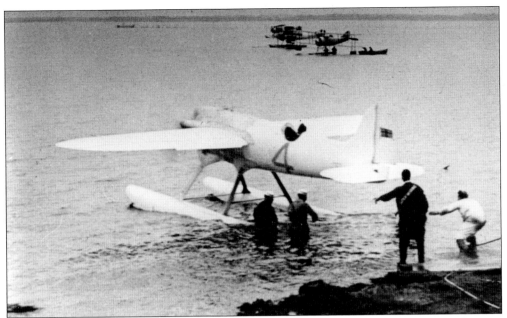

In October 1925, Baltimore's Bay Shore amusement park was the site of the Schneider Cup international competition for the world's fastest airplane. The contenders were all seaplanes. Shown here is the British Supermarine S.4, ancestor of the famous Spitfire. Although the S.4 held the existing speed record of 227 miles per hour, it crashed into the Chesapeake Bay, killing its pilot. (AACHS.)

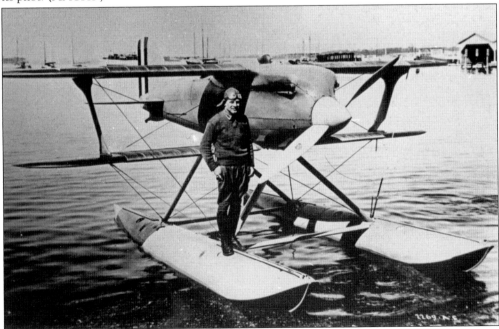

The winner of the 1925 Schneider Cup was U.S. Army lieutenant Jimmy Doolittle. Flying a Curtiss R3C-2, Doolittle flew seven laps of a 50-kilometer course across the Chesapeake Bay at a record-setting speed of 232 miles per hour, beating planes from Britain, Italy, and the U.S. Navy. (AACHS.)

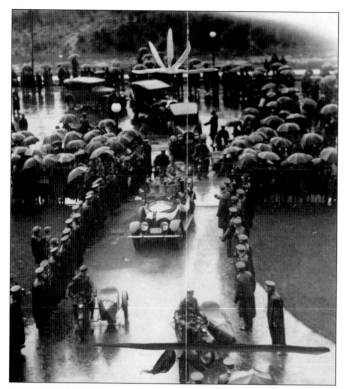

Just two months after his famous solo transatlantic flight in May 1927, Charles A. Lindbergh embarked on a nationwide tour of the United States, stopping at 92 cities across all 48 states. On October 18, nearing the end of this exhausting itinerary, he landed the *Spirit of St. Louis* in a driving rainstorm at Baltimore's Logan Field. After riding bareheaded in a motorcade to Baltimore Stadium, he addressed a crowd of 20,000, urging them to support commercial air travel. He was greeted by William F. Broening, mayor of Baltimore (left), and Albert C. Ritchie, governor of Maryland. The strain of the long tour is evident on the young aviator's face. (UMCP.)

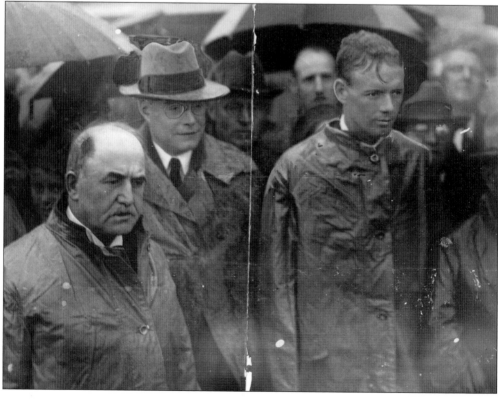

That evening, Lindbergh donned a tuxedo and, escorted by Mayor Broening and a contingent of Baltimore police, appeared at a welcome dinner attended by 1,200 civic leaders at the Lyric Opera House. He argued that aeronautics be taught in the public schools and new airports be built in every town and city. The following day, Lindbergh flew on to Wilmington. He had launched the "Lindbergh boom" in Maryland aviation. (UMCP.)

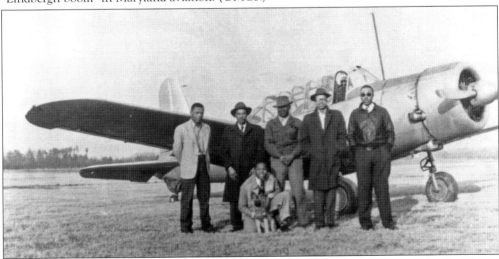

African Americans were barred from many early aviation activities. In 1940, Dr. Coleridge M. Gill and John W. Green Jr. (far right) rented a 450-acre farm near Croome in Prince George's County. Greene, a licensed pilot and mechanic, offered aeronautical training for African Americans, including the Civilian Pilot Training Program for students of Howard University. He also sponsored the "Cloud Club," pictured here with a Vultee BT-13 trainer. (MHT.)

Richard A. Henson was Maryland's most versatile aviation entrepreneur. In 1932, he opened a flying service at Hagerstown Airport while also serving as principal test pilot for Fairchild Aircraft. In the 1940s, he ran a branch of the Civilian Pilot Training Program and later became Fairchild's "million-dollar salesman." In the 1960s, he invented the commuter airline. (HAM.)

Dissatisfied with Hagerstown's once-daily service by Allegheny Airlines, Henson launched Hagerstown Commuter Airline in 1962, offering more frequent service between Hagerstown and Washington-area airports. Using a war-surplus Twin Beech and smaller planes, he competed successfully against Allegheny's larger equipment on these short routes. (HAM.)

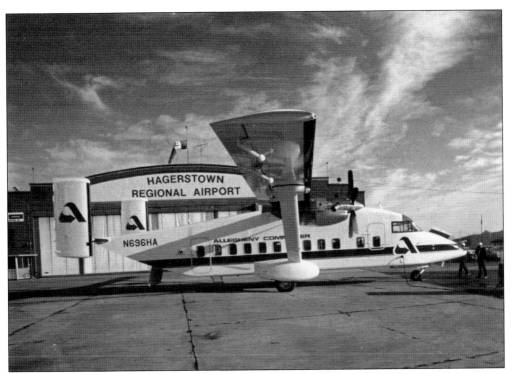

In 1967, Allegheny gave up and signed a contract with Henson's Hagerstown Commuter Airline to operate its services under the Allegheny colors, shown above on a Short 330. The "commuter airline" concept caught on across the country. (HAM.)

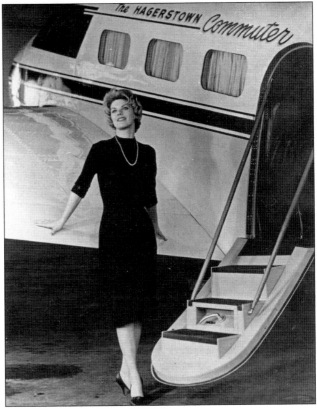

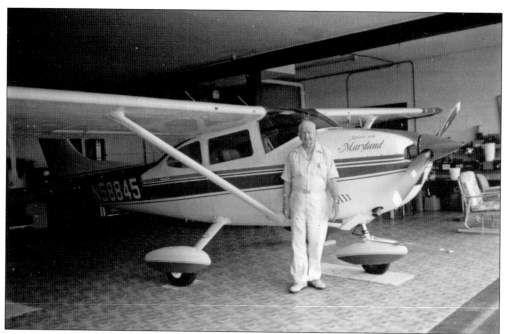

Nathan "Bill" Morris, posing in his home hangar, was a pioneer of general aviation in Maryland. Having first soloed in 1938, Morris flew for more than 65 years, accumulating more than 10,000 hours in the cockpits of light planes. In 2001, at age 94, he circled the continental United States in his Cessna 182-P *Spirit of Maryland*, flying solo. (MHT.)

Houses with attached hangars instead of garages line the grass runway of the Kentmorr Airpark on Kent Island. Bill Morris developed Kentmorr in 1945, the first of hundreds of residential "air parks" nationwide. Morris also developed the nearby Bay Bridge Airport. His *Spirit of Maryland* aircraft has been donated to the Glenn L. Martin Maryland Aviation Museum. (MAA.)

Two

MANUFACTURERS

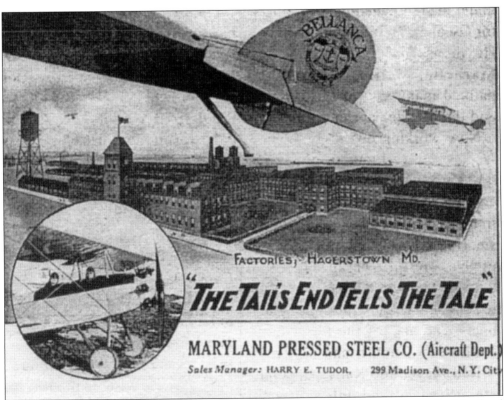

Maryland has long been important in aircraft manufacture. First in the field was the Maryland Pressed Steel Company of Hagerstown. In 1917, the company trumpeted the involvement of the noted designer Giuseppe Bellanca, who produced two experimental biplanes at Hagerstown. The end of World War I in November 1918 brought about the collapse of this venture. (HAM.)

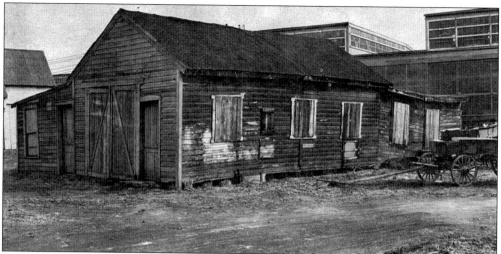

In 1926, Lewis E. Reisner and Ammon H. Kreider of Hagerstown decided to go into the aircraft business, operating out of the former Middlekaupf shoe shop on Walnut Street. Known affectionately as "the little green shed," the original Kreider-Reisner building stood for decades before being dismantled and preserved for later display by the Hagerstown Aviation Museum. (HAM.)

The first Kreider-Reisner product was the versatile Challenger biplane. Built with a variety of engines and configurations, the Challenger remained in production at Hagerstown until 1931; over 300 were built. The Hagerstown Aviation Museum collection includes a restored Challenger; so does the Smithsonian's Udvar-Hazy Center. (HAM.)

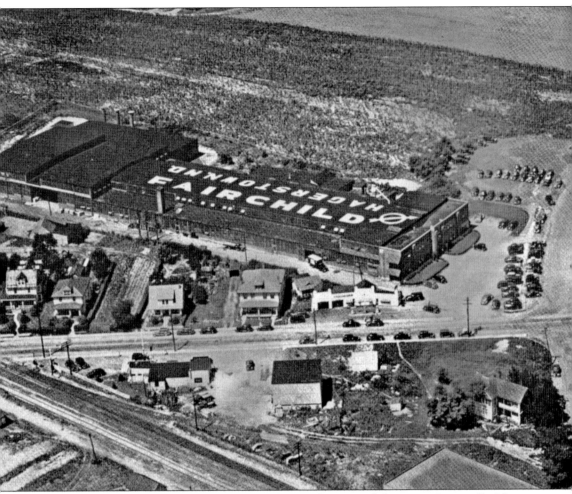

The New York investor Sherman Fairchild already owned an aircraft factory in Amityville, New York, when he purchased Kreider-Reisner in April 1929. By then, the company had expanded beyond the original green shed to several nearby buildings. Now, with the Lindbergh boom in full swing and with Fairchild's backing, a modern 32,000-square-foot factory was built alongside the original site. Flight-testing was moved to what is now the Hagerstown Regional Airport. (HAM.)

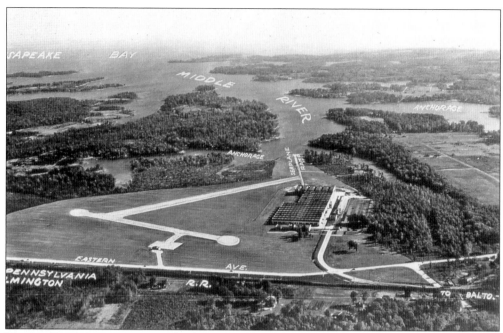

The Lindbergh boom, promoted by the Baltimore Association of Commerce, lured four aircraft-manufacturing plants to the city in 1928. Glenn L. Martin, initially attracted by the promise of a factory site at the new Municipal Airport, secretly purchased 1,240 acres in then-rural Middle River in Baltimore County. His new 239,000-square-foot plant, completed in October 1929, was among the largest and most modern in the country. (GLMMAM.)

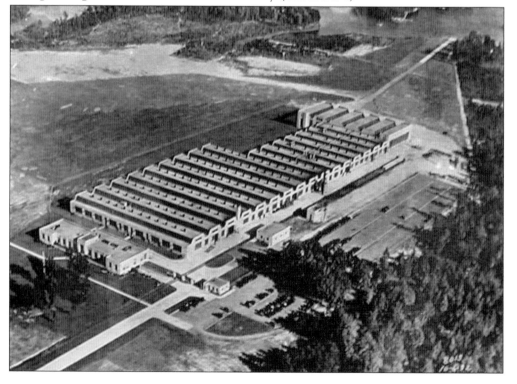

Glenn L. Martin was a genuine aviation pioneer. He built and flew his first airplane in California in 1910 and founded his first aircraft manufacturing company there in 1912. After originally building stunt planes, Martin turned to military designs, particularly after he moved his operations to Cleveland in 1918. Ten years later, he moved again, to Baltimore. This photograph was taken in the mid-1930s (Martin B-10s are in production in the background). By this time, Martin, though only in his 40s, was the "grand old man" of American aircraft builders. (GLMMAM.)

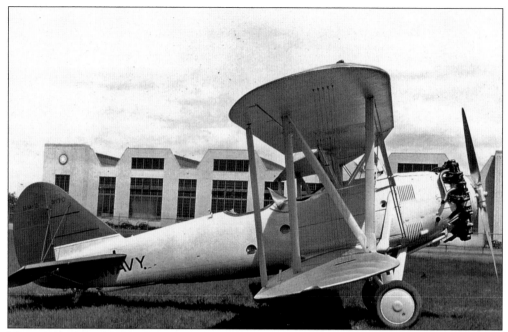

Martin's first Maryland-built production aircraft were the BM-1 and BM-2 series of navy bombers. The BM-2, shown in front of the brand-new Martin plant, was designed for the new technique of dive-bombing. It had to be sturdy enough to carry a 1,000-pound bomb into a 6,000-foot dive and pull out again without breaking up. This required the new stressed-skin aluminum structures that the new plant was tooled to produce. (GLMMAM.)

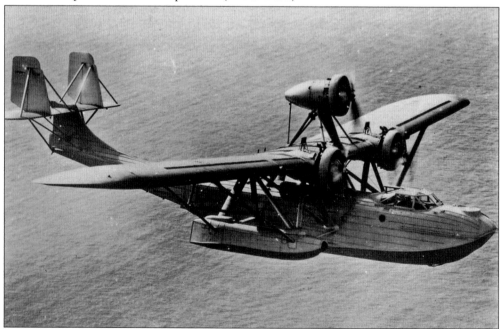

Conveniently situated on Dark Head Creek, a tributary of Middle River, the Martin plant also turned out a series of large navy flying boats in the late 1920s and early 1930s. Shown here is the XP3M-1. (GLMMAM.)

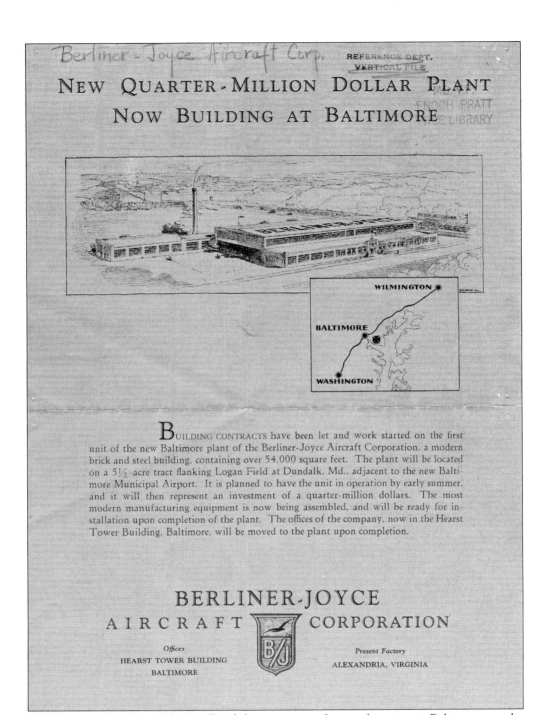

NEW QUARTER-MILLION DOLLAR PLANT
NOW BUILDING AT BALTIMORE

BUILDING CONTRACTS have been let and work started on the first unit of the new Baltimore plant of the Berliner-Joyce Aircraft Corporation, a modern brick and steel building, containing over 54,000 square feet. The plant will be located on a 5½-acre tract flanking Logan Field at Dundalk, Md., adjacent to the new Baltimore Municipal Airport. It is planned to have the unit in operation by early summer, and it will then represent an investment of a quarter-million dollars. The most modern manufacturing equipment is now being assembled, and will be ready for installation upon completion of the plant. The offices of the company, now in the Hearst Tower Building, Baltimore, will be moved to the plant upon completion.

BERLINER-JOYCE
AIRCRAFT CORPORATION

Offices
HEARST TOWER BUILDING
BALTIMORE

Present Factory
ALEXANDRIA, VIRGINIA

Another manifestation of the Lindbergh boom in aircraft manufacturing in Baltimore was the 58,000-square-foot Berliner-Joyce Aircraft Company factory, built on one of the development sites adjoining the new Baltimore Municipal Airport on the Dundalk waterfront. The plant still stands at 10 Maryland Avenue, just off Broening Highway in Turner's Station. (EPFL.)

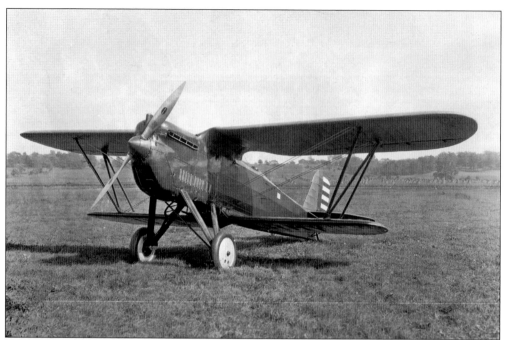

Berliner-Joyce won an army contract for the P-16 two-seat fighter. While the new Municipal Airport was incomplete, the company tested its planes on the nearby grass of Logan Field. (DO.)

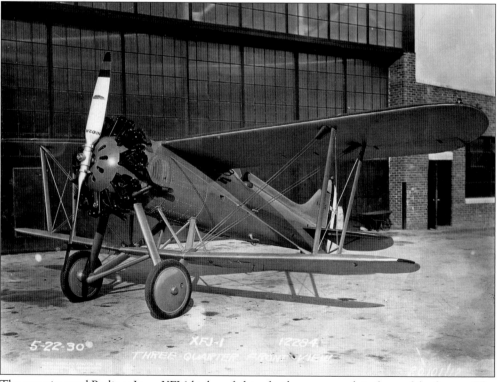

The experimental Berliner-Joyce XFJ-1 biplane fighter for the navy stands in front of the factory. The unusual wing configuration was supposed to give greater visibility for carrier landings. (DO.)

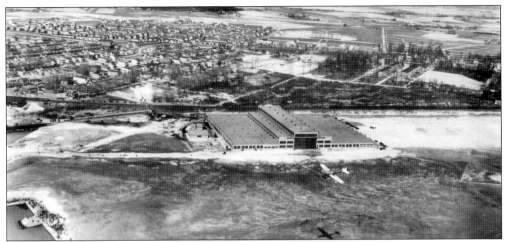

An even larger plant on the new Baltimore Municipal Airport site was constructed in 1929 by the Curtiss Caproni Corporation, a joint venture of American and Italian aircraft companies. But the new company failed to win any contracts before the Great Depression set in, and the 200,000-square-foot plant remained vacant during 1930. (EPFL.)

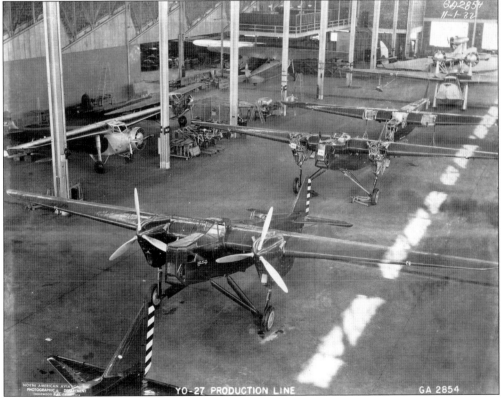

In 1931, the empty Curtiss Caproni plant attracted the General Aviation Corporation (GA), owned by General Motors. General Aviation had just absorbed the American Fokker Corporation and moved its activities from New Jersey to Baltimore. GA had a contract for 15 YO-27s, army observation planes of a new monoplane design. Shown here is the production line in the Baltimore plant. (DO.)

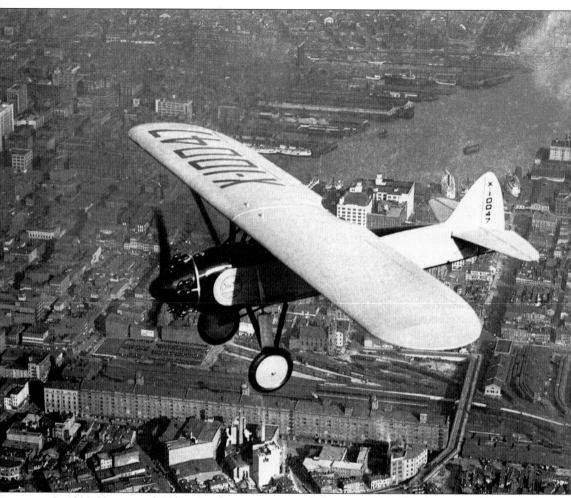

In 1928, Harvey and Wilson Doyle set up an aircraft factory at 3104 Elm Avenue in Hamden, the fourth new factory generated by the Lindbergh boom in Baltimore. Their principal product was the O-2 Oriole monoplane. The Doyle Aero Corporation was short-lived. In 1929, it was sold to Detroit Aircraft; the following year, after a serious fire at the factory, it was acquired by Davis Aircraft, which soon slid into bankruptcy. (MdHS.)

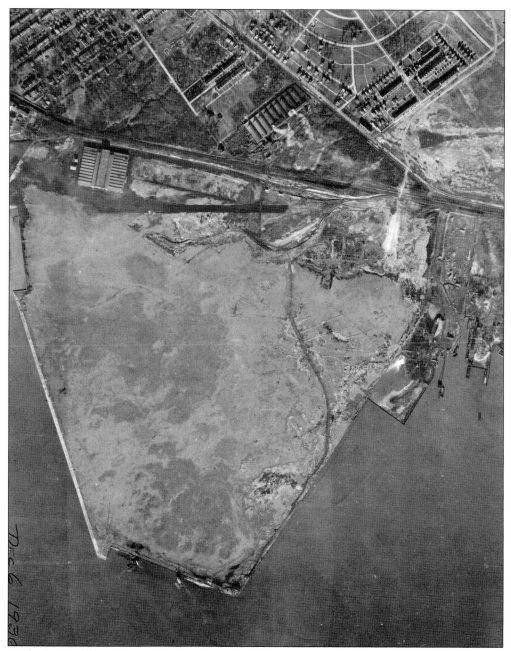

With the Lindbergh boom having brought four new aircraft plants to Maryland in 1929, advertisements hailed Baltimore as "the new capital of aviation." Late that year, however, the stock market crash led to the Great Depression. Orders for both civilian and military aircraft dried up. Baltimore City's plan to build a new municipal airport on new land in the harbor proved overambitious. Shown in 1936 is the incomplete site, with bulkheads in place but insufficient dredge spoil to build upon. The Curtiss Caproni plant is visible at top left, Berliner-Joyce at top center, and the end of a Logan Field runway at top right. (AACHS.)

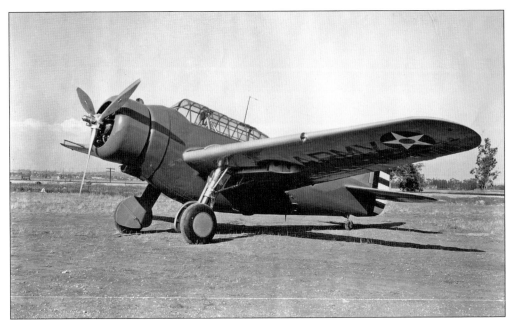

Late in 1928, North American Aviation, a holding company, bought an interest in Berliner-Joyce. In the depths of the Depression, North American also bought General Aviation. Now both of the Municipal Airport factories belonged to the same company. The new owners hired a former Martin executive, J. H. "Dutch" Kindelberger, to lead the new firm. Under his direction, the company produced the prototype O-47 observation plane for the army in 1934. (DO.)

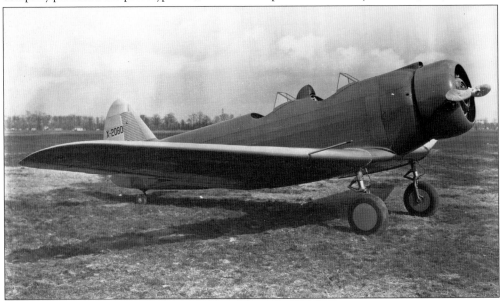

At the same time, North American's designers produced a prototype basic trainer. Under the designations BT-9, AT-6, Texan, and Harvard, this became one of the most important planes of World War II; more than 20,000 were built. Only the first was built in Baltimore, however. After obtaining initial orders from the army for 82 planes in 1935, Kindelberger moved the whole North American operation to Mines Field (now Los Angeles International Airport) in California. (DO.)

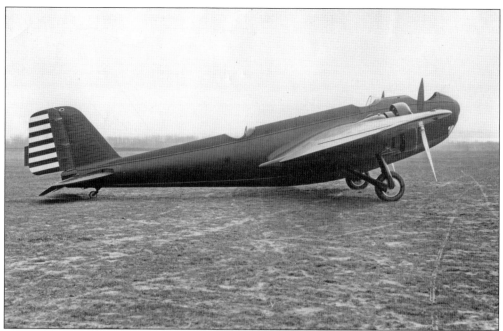

Glenn L. Martin had problems during the Depression as well. A stock offering to cover the construction loans for the new factory was forestalled by the crash; eventually Martin had to seek government financing to keep the plant open. A bright spot, however, was this prototype, the XB-907, for an all-aluminum streamlined monoplane bomber rolled out in February 1932. (GLMMAM.)

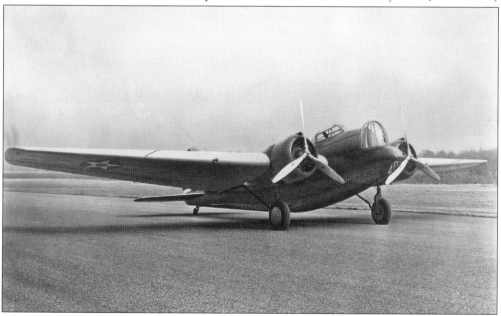

After improvements suggested by the air corps engineers at Wright Field, the XB-907 became the B-10, the world's most advanced bomber of its day. The B-10 could exceed 200 miles per hour, faster than most contemporary fighters—so fast that the nose gunner required a Plexiglas turret. Despite the Great Depression, the army ordered 105 B-10 variants. The factory designation was Martin Model M-139. (GLMMAM.)

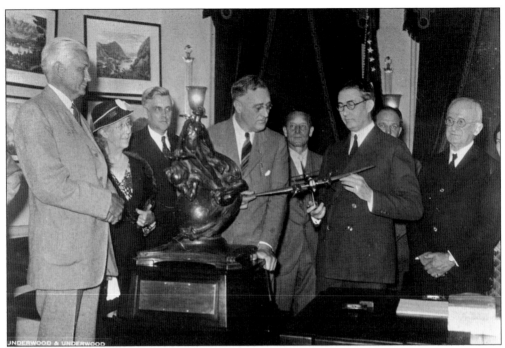

In 1933, the B-10 design won the annual Collier Trophy for aeronautical achievement, presented to Glenn Martin (holding model) and his mother, Minta (second from left), in the White House by Pres. Franklin D. Roosevelt. (GLMMAM.)

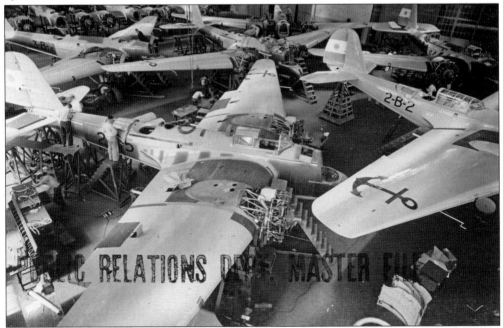

Inspired by the B-10 to develop even larger and faster bombers, the air corps released the M-139 design for export in 1935. Martin sold 192 planes to foreign customers. Here M-139s for the Argentine navy crowd the final assembly floor at the Martin plant. One of the Argentine planes, restored by the U.S. Air Force Museum, is the only survivor of the type. (GLMMAM.)

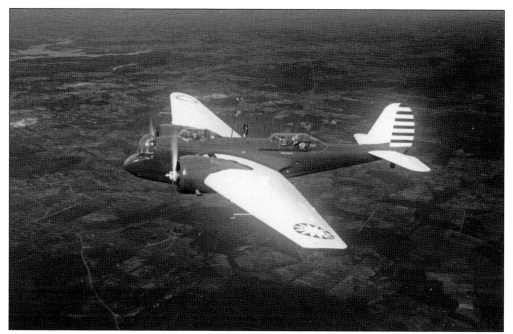

One of nine M-139s sold to China displays the plane's unique three-cockpit profile. In 1938, Chinese Martins bombed Nagasaki in Japan—though the distance was so great that their payload was only leaflets. Other M-139 sales were to Siam, the Soviet Union, Turkey, and the Netherlands East Indies. (GLMMAM.)

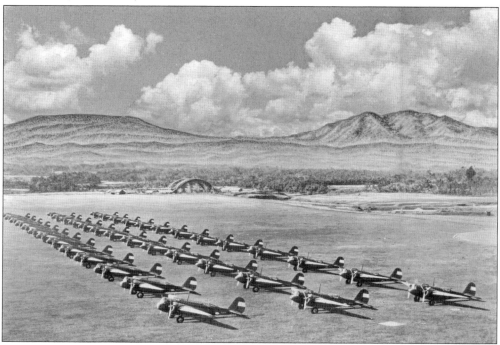

The Dutch were Martin's best customers, buying 120 M-139s—the biggest multi-engine bomber force in Asia—to defend their Indonesian colonies. Without adequate fighter escort, however, they were unable to stop the Japanese onslaught of 1941–1942. (GLMMAM.)

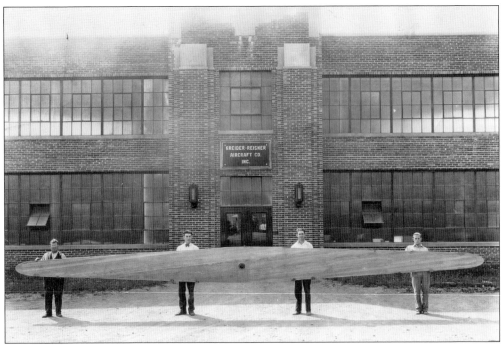

The Great Depression also affected the fortunes of Fairchild Aircraft in Hagerstown. With sales of the Challenger biplanes nonexistent, the company put its new factory to contract work, like the autogiro rotor blade displayed in front of the plant entrance. It was produced for Kellett Aircraft of Philadelphia. (HAM.)

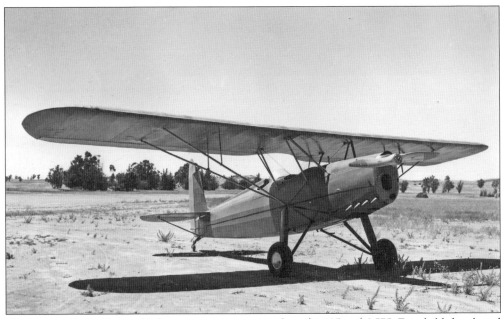

Unable to sell Challenger biplanes at prices ranging from $4,485 to $6,575, Fairchild developed the Model 22 parasol monoplane in 1931. The price was less than $3,000; 128 were sold between 1931 and 1935. (HAM.)

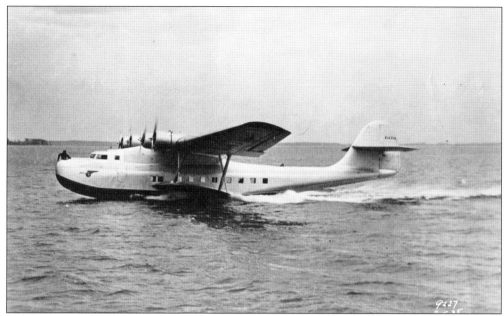

In 1934, Martin engineers applied to a commercial airliner the aerodynamic techniques successfully employed in the B-10. The new design, a four-engine flying boat, could lift more than its own weight, enabling it to carry sufficient fuel to transport paying passengers and mail on the longest airline route in the world, the 2,410 miles between San Francisco and Honolulu. Martin's M-130 was the first true intercontinental airliner. (GLMMAM.)

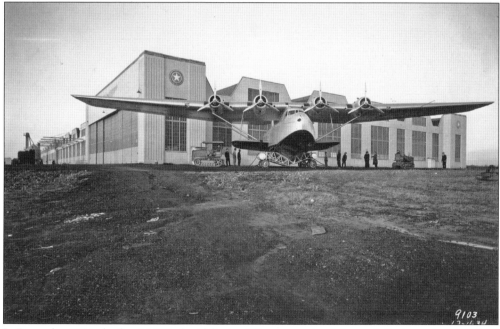

In December 1934, the first M-130, the *Philippine Clipper*, was wheeled on a dolly down the ramp from the Martin plant to be launched in Dark Head Creek. Pan American Airways bought three M-130 "clippers," naming them for their three most important Pacific Ocean destinations: Hawaii, the Philippines, and China. All three planes came to be known as China Clippers. (GLMMAM.)

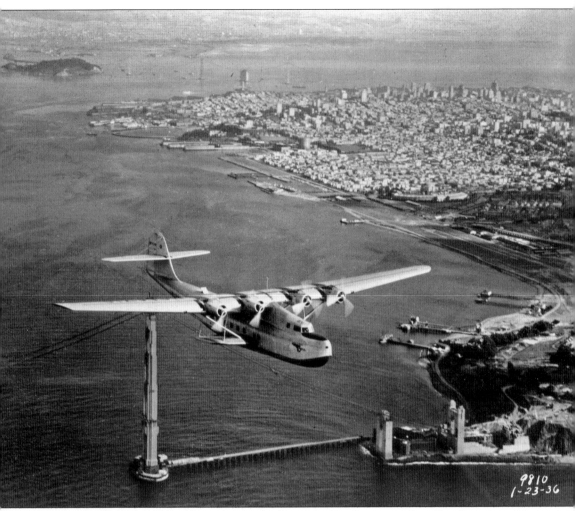

In October 1936, the *China Clipper* began the first trans-Pacific service from San Francisco. The flight aroused great enthusiasm, with 125,000 people gathering at Alameda to see the ship off and millions more listening on a national radio network. It took the clipper 60 flying hours to reach Manila, with overnight stopovers at Pan Am hotels on Oahu, Midway, Wake, and Guam. This service lasted until the Japanese attacks of December 1941, after which the aircraft were taken into government service. All three M-130s had fatal ends. The *Hawaii Clipper* mysteriously disappeared over the Pacific in 1938. The *Philippine Clipper* crashed into a mountain near San Francisco in 1943. Longest-lived was the *China Clipper*, which logged three million miles before being destroyed in a landing accident in Trinidad in 1945. Its most important wartime cargo was uranium ore from the Belgian Congo, an essential part of the effort to build the atomic bomb. (GLMMAM.)

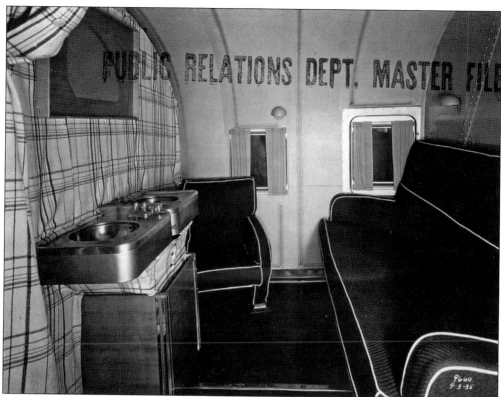

The China Clippers' cabins were decorated in art deco luxury. Nevertheless, the 20-hour San Francisco–Honolulu flight at low altitude beneath four thundering piston engines must have been arduous. On this long flight, only 10 passengers could be carried, along with almost an equal number of crew members. Seats could be converted into Pullman-style bunk beds; divans became folding sinks. (GLMMAM.)

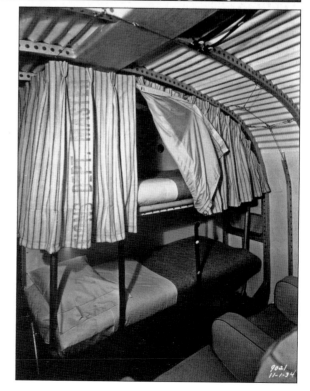

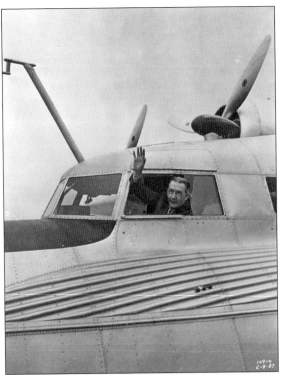

Glenn Martin waves from the *China Clipper* cockpit on a promotional flight in 1937. To Martin's dismay, Pan Am turned to the larger Boeing Model 314 for its next generation of clippers. Since Martin had sold the three planes at the bargain price of $417,000 each, the company had to write off $500,000 of development costs. (GLMMAM.)

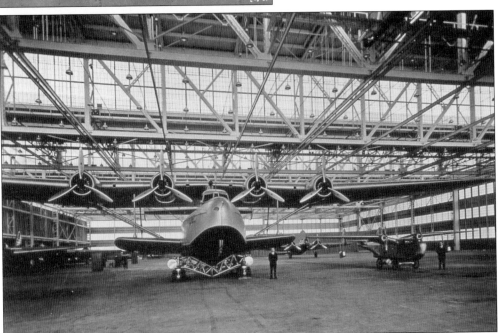

Glenn Martin recouped some of this loss when in 1937 the Soviet Union paid over $1 million for an upgraded clipper along with tools and plans for factory production in the Ukraine. Inevitably dubbed the *Soviet Clipper*, the M-156 is shown in a new addition to the Martin plant intended for the manufacture of large flying boats. Known as B Building, it measures 300 by 450 feet with no internal columns. (GLMMAM.)

B Building (still standing in Middle River) is a masterpiece of the Detroit factory architect Albert Kahn. By using huge steel bridge trusses, Kahn was able to carry windowed roof monitors across the huge open space. Sixty percent of the walls and ceiling are of glass. Along one side is an enormous door, 300 feet wide and 43 feet high. (GLMMAM.)

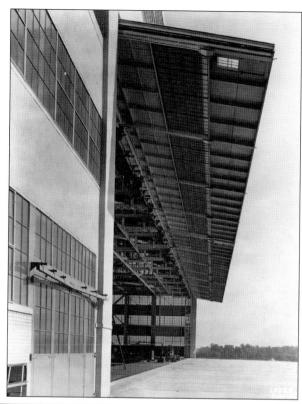

After losing most of the development costs on the China Clippers, Martin attempted to economize by building a 3/8-scale model instead of a full-sized prototype for a new flying-boat patrol bomber for the navy. The *Tadpole Clipper* (Martin Model M-162A) was powered by an automobile engine with chain drives to the craft's two propellers. (GLMMAM.)

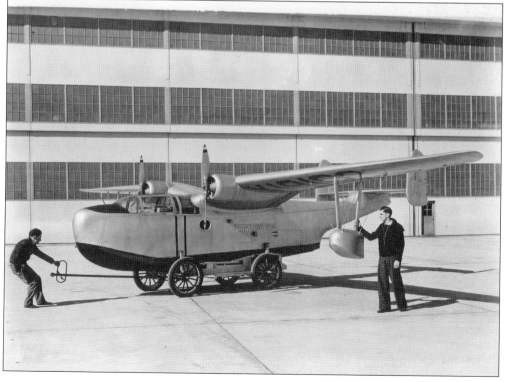

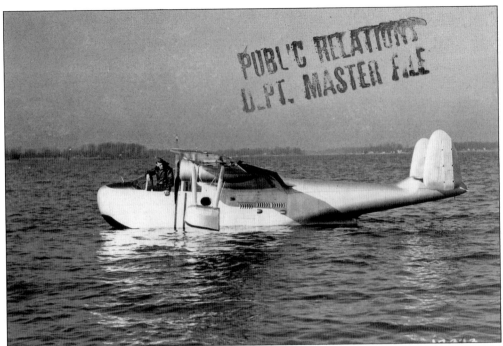

The M-162A was actually flown in order to gather performance data for a large flying boat powered by two big radial engines, a cheaper alternative to four-engine flying boats like the Consolidated Coronado. (GLMMAM.)

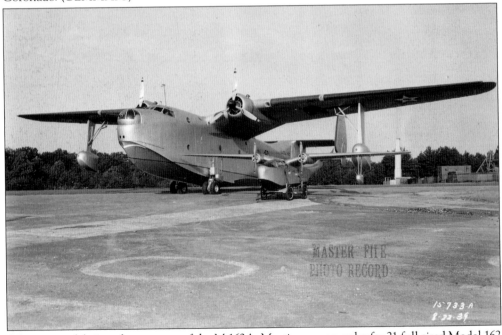

After successful air and water tests of the M-162A, Martin won an order for 21 full-sized Model 162 PBMs in 1938. The *Tadpole Clipper* (shown here alongside a full-sized PBM) was donated to the Smithsonian. Fully restored by members of Chapter 146 of the Experimental Aircraft Association, it is now on display at the Baltimore Museum of Industry. (GLMMAM.)

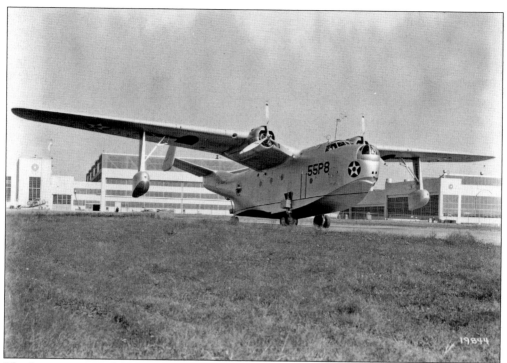

The first service models of the PBM were delivered in 1941, in time to fly in "neutrality patrols" over the Atlantic in the months before Pearl Harbor. The growing Martin Plant No. 1 is visible in the background. (GLMMAM)

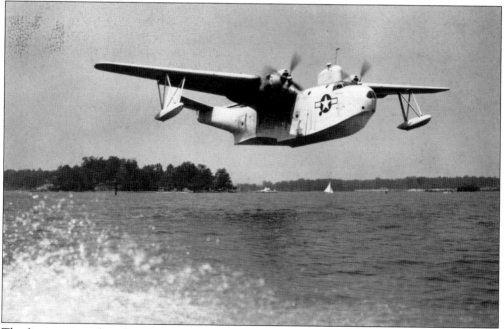

The first mass-produced model of the PBM was the PBM-3, of which 677 were built between 1941 and 1943 in bomber, cargo, and antisubmarine patrol versions. This is a PBM-3S antisubmarine aircraft in Atlantic gull-gray camouflage; PBMs sank 10 German U-boats. (GLMMAM.)

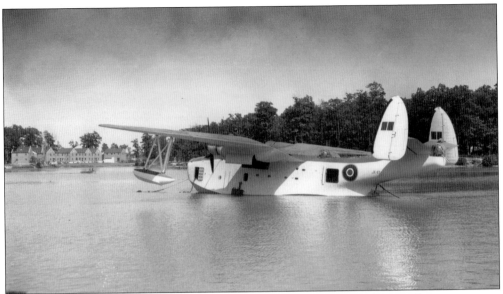

The British Royal Air Force received 31 PBM-3s under Lend Lease. Preferring alliterative names to the U.S. alphanumeric designations, they christened the M-162/PBM the Mariner. Here a RAF Mariner is anchored in Dark Head Cove next to the Martin-built Stansbury Manor Apartments. (GLMMAM.)

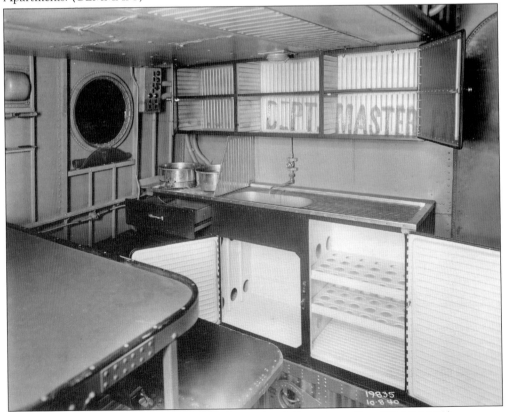

The PBM was equipped for long patrol flights with a full-service galley. (GLMMAM.)

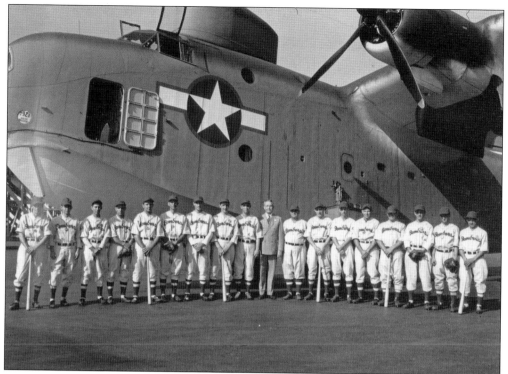

Most PBMs were flown to Norfolk for secret modifications by the navy. The fiberglass "doghouse" behind the cockpit housed the latest radar. Here Glenn Martin poses in front of one along with the factory baseball team, the Bombers (naturally). (GLMMAM.)

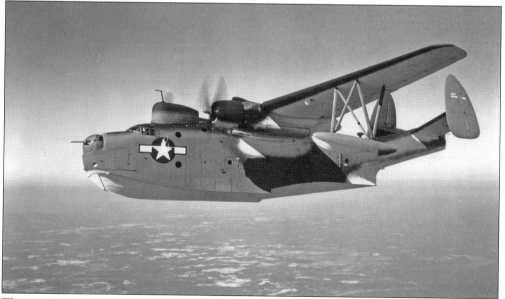

The two Wright R-2600 engines on the PBM-3 left it somewhat underpowered. The 667 PBM-5s built between 1944 and 1946 carried larger Pratt and Whitney R-2800 engines. Larger air scoops atop the engines differentiate the two models. Only one PBM, a -5A amphibian, survives. It is on display at the Pima Air and Space Museum in Tucson, Arizona. (GLMMAM.)

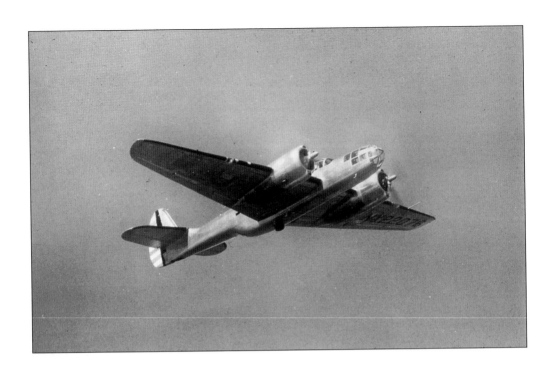

It was this design, Model 167, that finally brought the Glenn L. Martin Company out of financial difficulties in the 1930s. Streamlined and speedy, the M-167 was built to compete for a new Army Air Corps specification for an attack bomber to support troops in the field. Martin's entry, designated XA-22 by the army, was built at the company's expense early in 1939. Although the Douglas A-20 won the army contract, Martin was paid $505,390 toward development costs. More significantly, the M-167 attracted the attention of a French government purchasing mission. Hitler's threats at the Munich conference made the French desperate to buy modern aircraft. They ordered 495 M-167s for delivery beginning in July 1939. (GLMMAM.)

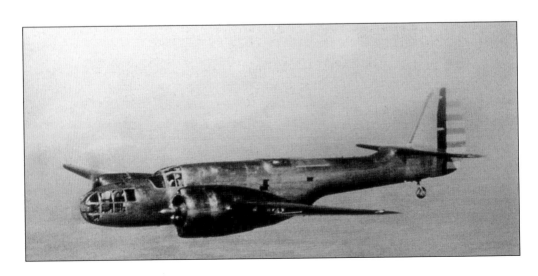

Martin declared that he could not complete the M-167 order in time without expansion of the factory. Accordingly, the French government added $2.5 million to the contract for an addition. Martin's architect, Albert Kahn, was summoned from Detroit, arriving on a Friday. The first contracts were let on Saturday. Work began Monday morning and proceeded around the clock until the new factory, Martin's C Building, was completed in April. (GLMMAM.)

C Building's 144,000 square feet of factory floor were lit by extensive ribbon windows in the side walls and glass "butterfly" roof monitors. After completing the new building in only 77 days, Martin began hiring more than 8,000 new workers. These events in 1939 really marked the beginning of World War II in Baltimore. (GLMMAM.)

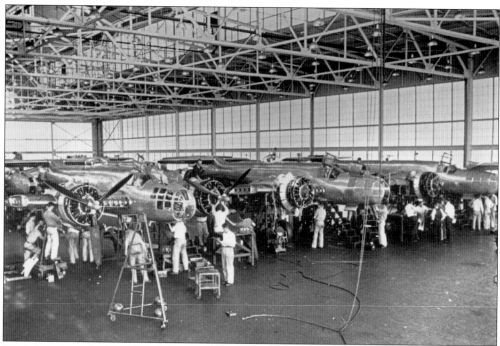

Work began on the French contract even before the new factory was finished. Here Model 167s are in the final assembly hall of C Building. (GLMMAM.)

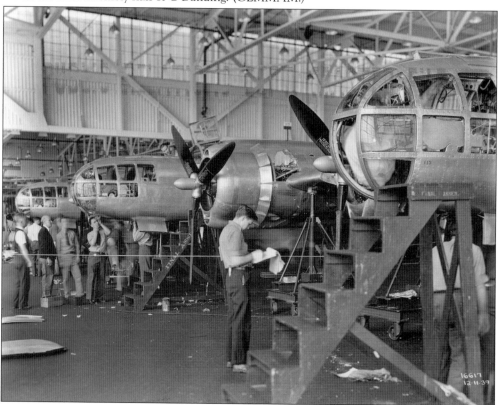

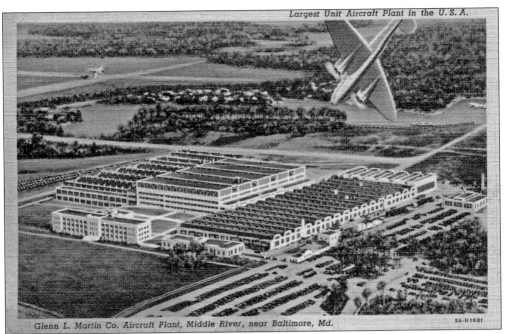

Largest Unit Aircraft Plant in the U. S. A.

Glenn L. Martin Co. Aircraft Plant, Middle River, near Baltimore, Md. 9A-H1601

The adjoining A, B, and C Buildings of the Martin plant enclosed 1.5 million square feet, matching Martin's original master plan for the site. At the end of 1939, it was the largest single aircraft factory in the United States. (Author's collection.)

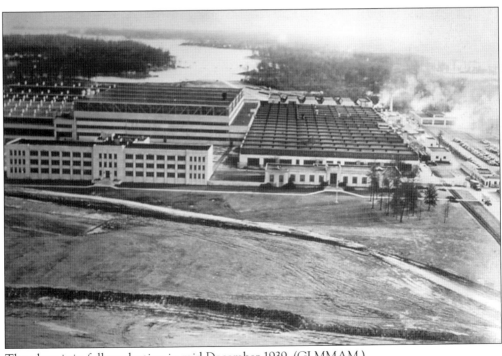

The plant is in full production in mid-December 1939. (GLMMAM.)

Martin missed the first production deadline, but a first shipment of M-167 bombers was ready by early September 1939. Since they lacked the range to fly the Atlantic, the planes were shipped in crates. Here the first shipment of crated aircraft leaves the factory on September 2, 1939. The next day, France declared war on Nazi Germany, and all shipments were embargoed under the U.S. Neutrality Act. (GLMMAM.)

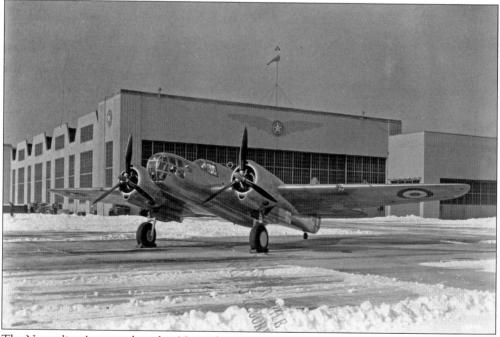

The Neutrality Act was altered in November to enable "cash and carry" shipments. The French navy sent a battleship and an aircraft carrier to convoy the first shipment of M-167s to Casablanca, where training could proceed during the winter of 1939–1940. Here a new M-167 in French markings stands outside A Building. (GLMMAM.)

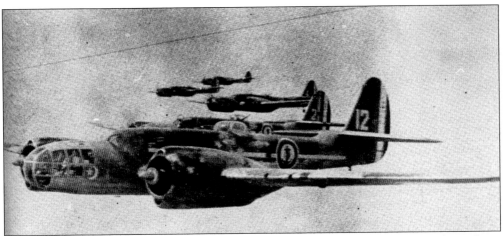

French pilots liked the M-167, which they dubbed the "Glenn." But the half-trained squadrons were not enough to stop the German invasion of France in May 1940. After the French surrender, Glenns continued to fly for the Vichy French air force and navy from France's North African colonies. Aeronavale M-167s like these attacked the British fleet in Gibraltar and the British and American landings of Operation Torch in November 1942. (GLMMAM.)

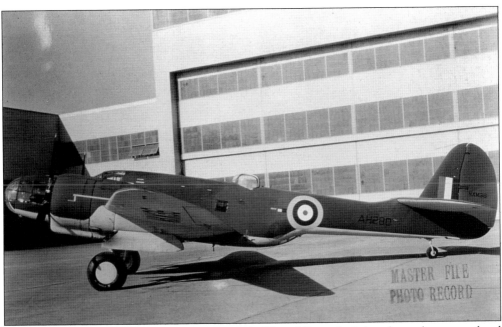

Jean Monnet, France's chief purchasing agent in the United States, had signed over the uncompleted French contracts to the British. Approximately 310 M-167s were delivered to the French; 185 went to the British. Always fond of alliterative names for aircraft types, the British christened the plane the Martin Maryland. Here a Maryland with British insignia is shown in front of B Building in December 1940. (GLMMAM.)

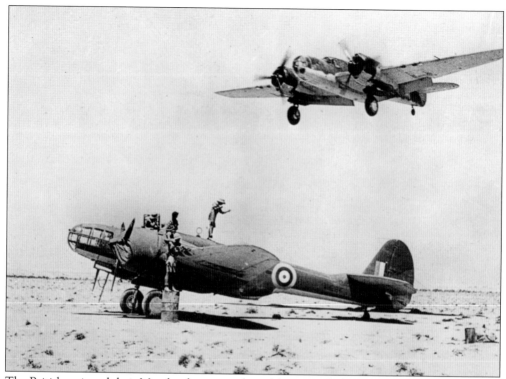

The British assigned their Marylands to a number of duties, including spy flights in their original French markings. Most, however, were assigned to Royal Air Force and South African Air Force squadrons in the Egyptian desert, fighting the German Afrika Corps. (GLMMAM.)

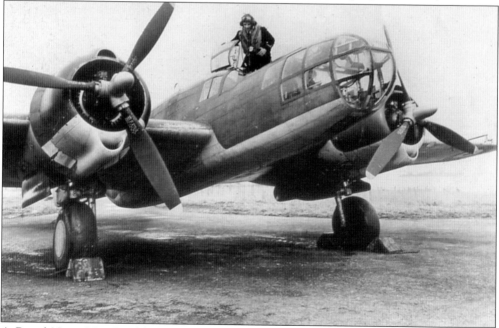

A Royal Navy Maryland helped track the German battleship *Bismarck* in the spring of 1941. (GLMMAM.)

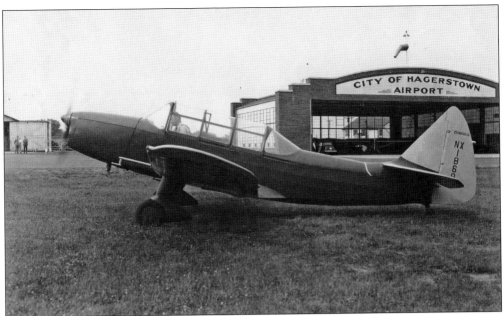

Another military aircraft order ended the lean years of the Great Depression for Fairchild in Hagerstown. This was an innovative design for a primary training plane. With war clouds gathering, pilot training was a high priority. In 1938, the Fairchild designer Armand Thieblot conceived of a monoplane trainer that resembled modern combat aircraft rather than the biplanes traditionally used in pilot training. Pictured here is the prototype Fairchild Model 62. (HAM.)

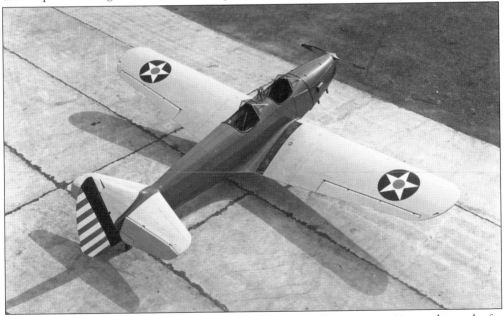

During the summer of 1939, the Model 62 won an Army Air Corps competition and an order for 270 planes, Fairchild's biggest government order to date. Modified as an open-cockpit primary trainer, the plane was designated PT-19 by the army. Most PT-19s were powered by six-cylinder Ranger engines, also built by Fairchild at a separate division of the company in New York. Many more orders were to follow. (HAM.)

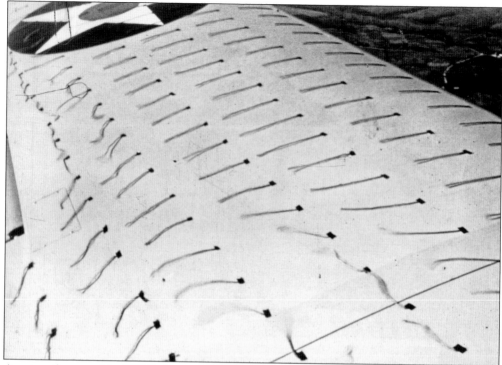

A unique feature of the PT-19's design was intended to combat dangerous stall conditions in steep climbs. Instead of the conventional wing shape, in which the stall's break in airflow began at the wing tips and soon caused the ailerons to lose their "bite," Thieblot gave the PT-19's wings a twist that moved the break in airflow to the wing root, where it caused fewer problems of control. The differences in airflow are visible in the pattern of ribbons in this test wing. (WCHS.)

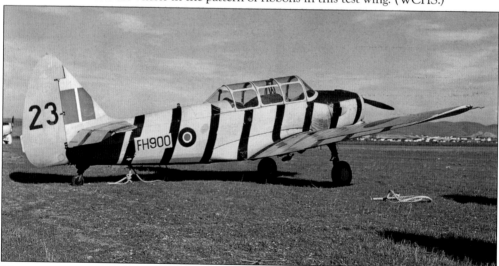

Many more contracts followed for a variety of versions. The PT-23 was powered by a radial engine; the PT-26, developed for the British Empire Pilot Training Scheme in Canada, went back to an enclosed cockpit, better suited to Canadian weather. Like the British, the Canadians preferred names for aircraft rather than alphanumerics. Trainers were named after universities: the PT-26 became the Cornell. (HAM.)

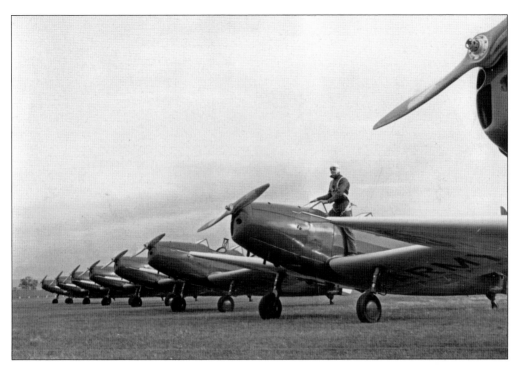

More than 5,000 PT-19s were built by Fairchild at Hagerstown. Other manufacturers included Aeronca, Howard, St. Louis Aircraft, Fleet Aircraft of Canada, and Fabrica do Galeao of Brazil. During World War II, more Allied pilots learned to fly in Fairchild primary trainers than in any other aircraft type. Numerous PT-19s are preserved, including three at the Hagerstown Aviation Museum. (HAM.)

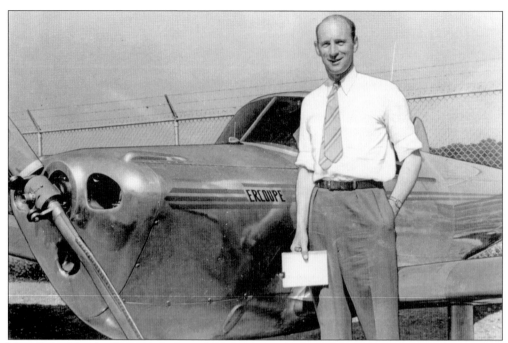

Not all the Maryland aviation news of the late 1930s had to do with war. The Engineering and Research Corporation, founded by Henry Berliner in 1932, developed an innovative personal airplane designed for safety by Frederick E. Weik, another winner of the Collier Trophy. In 1928, ERCO moved into a modern factory and airport in Riverdale; in early 1940, production began on the Ercoupe, named after the initials of the company. (MHT.)

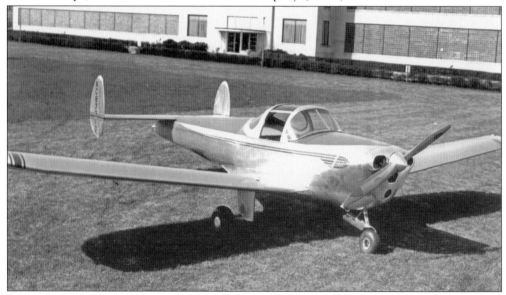

Weik's design for the Ercoupe included such novelties as aluminum construction, tricycle landing gear, anti-stall aerodynamics, and easy pilot control by a steering wheel without separate rudder pedals. Wartime priorities shut down the production line after only 112 planes were produced. The factory then shifted to making aircraft gun turrets; nearly 4,000 workers were employed during World War II. (MHT.)

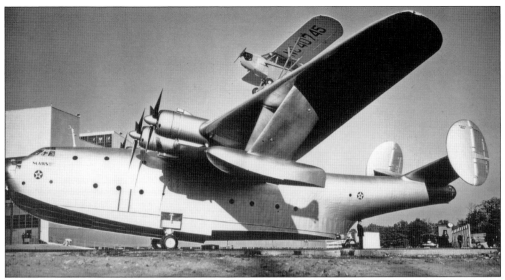

Just a month before Pearl Harbor, Martin Aircraft launched the giant Mars flying boat, shown in a publicity photograph with a Piper Cub on each wing. Originally conceived as a bomber (a "flying dreadnought"), the Mars excelled as a cargo plane. The initial aircraft, known as the "Old Lady" at Martin, could carry 25,000 pounds of priority cargo over the long San Francisco–Honolulu route. (GLMMAM.)

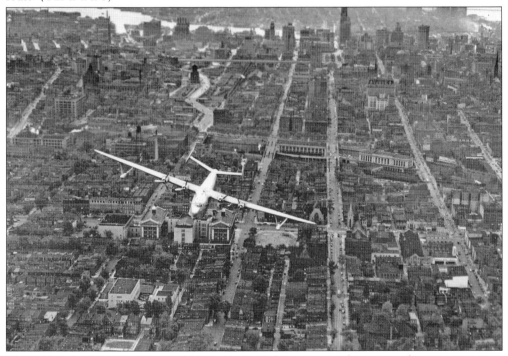

The Old Lady flies over Twenty-fifth Street in Baltimore upon her return from setting cargo records in the Pacific. At the height of the U-boat campaign in 1942, there was thought given to building a whole Mars fleet to carry cargo safely across the submarine-infested Atlantic. Henry Kaiser and Howard Hughes pursued the idea, eventually building the wood-construction "Spruce Goose," even larger than the Mars. (GLMMAM.)

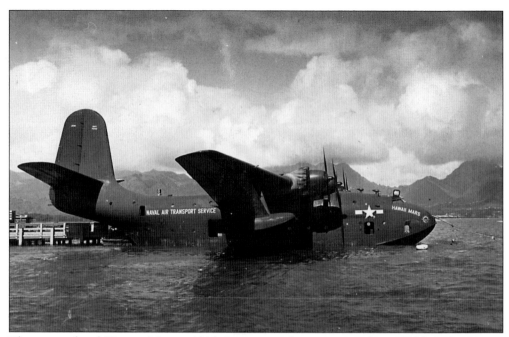

The navy ordered 20 more Mars in 1944, designating them as cargo planes, JRM. Only six were complete at the end of the war, when the contract was terminated. Until 1956, the JRMs were the workhorses of navy's Pacific Ocean cargo operations, carrying priority shipments to the Korean War and wounded soldiers back home for treatment. (GLMMAM.)

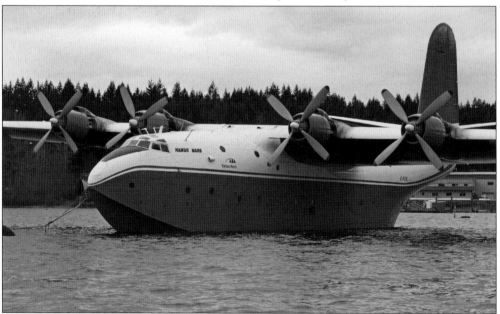

When the navy auctioned off the Mars fleet in 1959, the buyer was Forest Industries Flying Tankers Ltd. of British Columbia. The company and its successor, Coulson Air Tankers, have kept them flying ever since as "water bombers," ingeniously modified to scoop up huge quantities of lake water to drop on forest fires. Two of these remarkable planes are still flying in Canada, more than 60 years after their construction. (GLMMAM.)

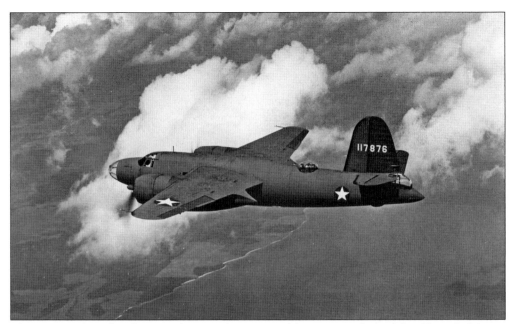

The B-26 medium bomber was the most famous World War II product of the Glenn L. Martin Aircraft Company. Ordered in 1939 without a prototype, the first B-26 was rolled out in November 1940. British purchasing officials were so impressed that they placed an immediate order for 395 planes. Although deliveries to the Royal Air Force did not begin until 1942, the British alliterative name "Marauder" was immediately applied. (GLMMAM.)

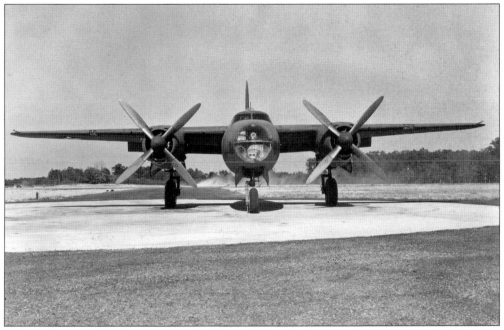

What so impressed observers was the Marauder's radical streamlining: a tapered cylindrical fuselage with tricycle landing gear; huge nacelles, also cylindrical, for the plane's two big radial engines; and the stubby 65-foot wings that gave the B-26 higher performance, though at the cost of high landing speeds. (GLMMAM.)

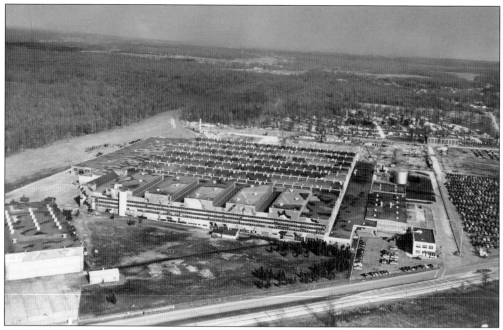

In September 1940, before the first B-26 had even flown, the army placed large orders as part of President Roosevelt's 50,000-plane program. Martin's Plant No. 2 at Middle River, equal in size to Plant No. 1 about a mile away, was built to produce Marauders. So was an identical branch plant in Omaha. (GLMMAM.)

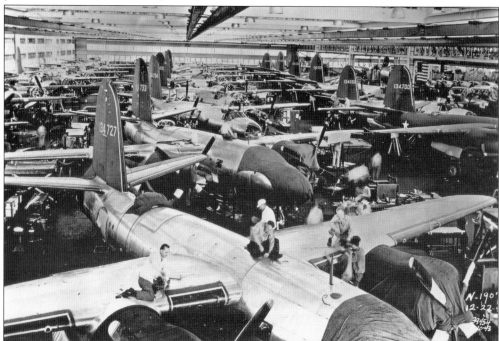

Beneath glass-and-steel roof monitors characteristic of the designs of Albert Kahn, B-26s move towards completion at Martin Plant No. 2 in 1942. The Middle River plant built 4,056 Marauders, and another 1,210 were built at the Omaha plant. (GLMMAM.)

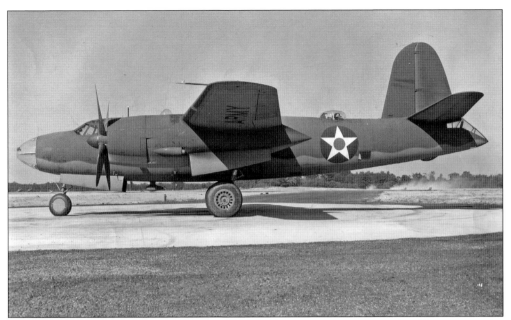

In the months after Pearl Harbor, early-model B-26s went into action in the Aleutians, at the Battle of Midway, and in Australia and New Guinea. Although praised by combat pilots for its speed and rugged construction, the Marauder was more difficult for novice pilots to fly than the other U.S. medium bomber, the B-25 Mitchell. After a number of crashes at training bases, the B-26 was widely criticized. (GLMMAM.)

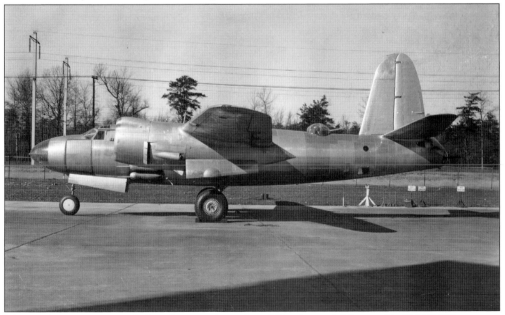

Martin designers responded with a number of modifications visible on this B-26F. Wings were lengthened from 65 to 71 feet and twisted 3.5 degrees upwards for better performance in landings and takeoffs. Also added were extra machine guns in external fuselage fairings beneath the cockpit. Training accidents fell off, and Marauders in the European theater won a reputation for bringing their crews home safely. (GLMMAM.)

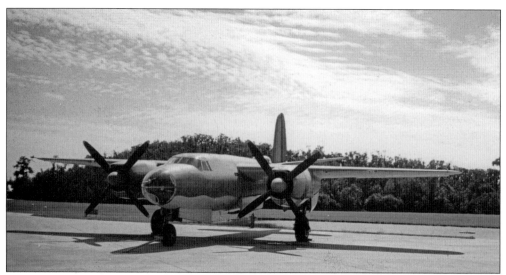

The Marauders of 9th Air Force flew tactical missions over France and Germany between 1943 and 1945, most notably on D-Day, when 293 B-26s made low-level attacks on the German defenses at Utah Beach. At the war's end, the B-26 Marauder was declared obsolete; the B-26 designation was transferred to the Douglas Invader (formerly the A-26). Almost all Marauders were scrapped. Few survive today. This early short-wing Marauder, in Kermit Weeks's Fantasy of Flight museum in Florida, was reconstructed from parts gathered by David Tallichet from a crash site in northern Canada. Another restored Marauder is on display at the U.S. Air Force Museum. Part of a Marauder fuselage can be seen at the National Air and Space Museum. (Author's collection.)

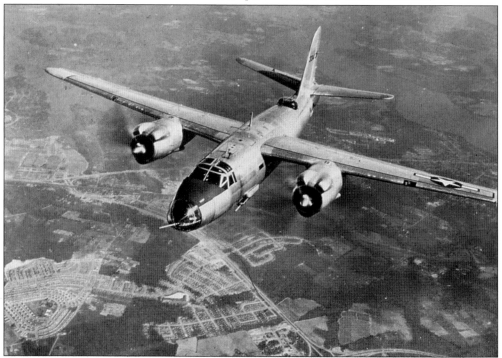

A B-26 flies over the wartime community of Middle River, described as "the town a bomber built." (GLMMAM.)

In May 1940, a joint British-French purchasing mission ordered a follow-on to the Martin Model 167. The British wanted more space inside the plane and more powerful engines. The result was the Model 187 light bomber, dubbed the Baltimore; 400 were ordered. After the French surrender, the entire order went to the British. After completing the original contract, Martin went on to produce 1,175 more under Lend Lease. (GLMMAM.)

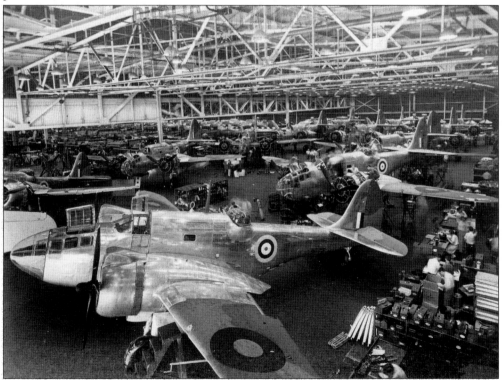

Baltimores under construction in C Building of Martin Plant No. 1 bear British markings. They also served in the Royal Australian Air Force, South African Air Force, Hellenic Air Force, Turkish Air Force, and (after Italy's surrender) the Italian Air Force. These small, speedy bombers were used almost exclusively in the Mediterranean theater. (GLMMAM.)

Martin test pilots stand with the last Baltimore produced in May 1944. Since the Baltimore carried only one pilot, its fuselage only needed to be wide enough for his shoulders, yielding the curious slab-sided or fishlike look to the plane. Although given the U.S. designation A-30, no Baltimores served in the U.S. Air Forces. None of the 1,575 planes survives today. (GLMMAM.)

Glenn Martin shakes hands with Pres. Franklin D. Roosevelt on the occasion of the president's visit to the expanding Martin plants on September 30, 1940. Roosevelt was campaigning for a third term. (GLMMAM.)

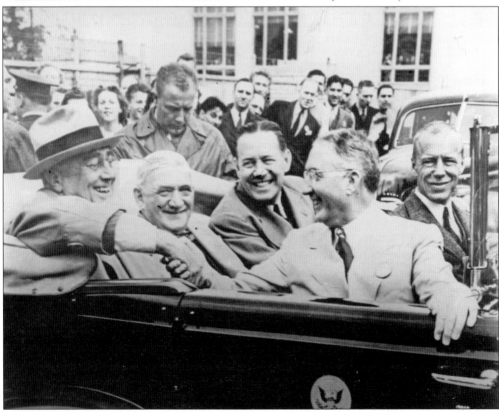

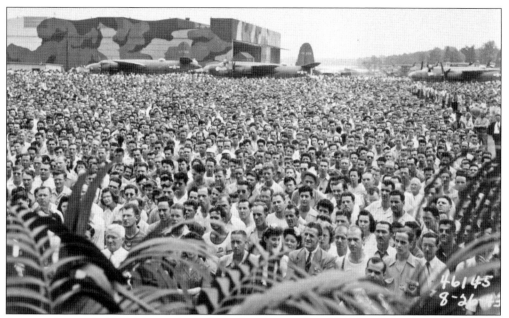

At its peak in early 1943, Martin Aircraft employed more than 53,000 in Baltimore. They worked three shifts around the clock at the main plants in Middle River and at several other locations. Here, in August 1943, thousands of Martin workers welcome veteran B-26s and their crews home from combat. (GLMMAM.)

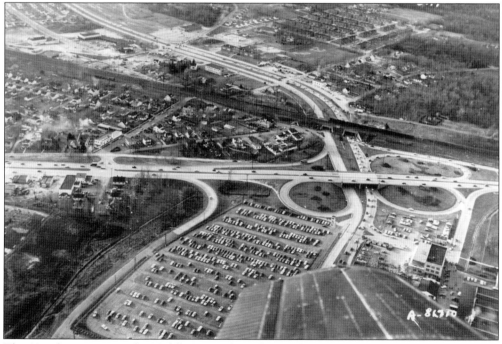

The 10 miles separating the Middle River plants from Baltimore made for epic traffic jams. Two new dual highways, Martin Boulevard from the west (top of photograph) and Eastern Boulevard from the south, eased traffic somewhat. They met in front of Plant No. 1 in what is probably Maryland's first cloverleaf interchange. (GLMMAM.)

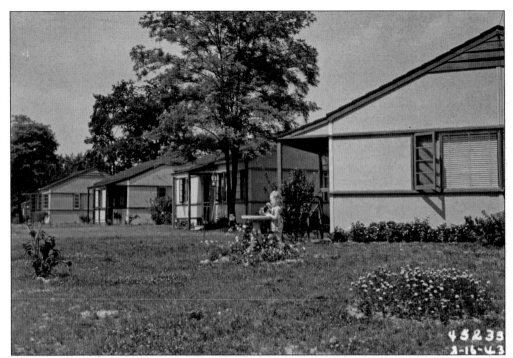

Another way to deal with the traffic problem was to build houses near the Martin plants. The company took the lead, erecting the Stansbury Manor Apartments in 1939 and 600 single-family houses at Stansbury Estates and Aero Acres in 1941. Designed by the architects Skidmore, Owings, and Merrill, these small prefabricated houses were constructed quickly and boasted two bedrooms and picture windows. (GLMMAM.)

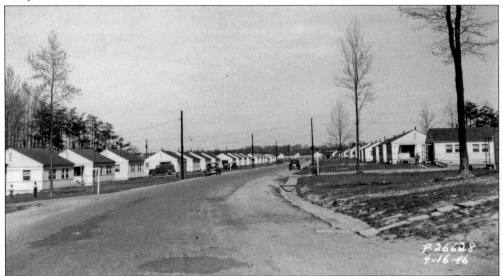

Soon the Martin plants were surrounded by trailer parks, garden apartments, and 1,000 small prefabs built by the federal Farm Security Administration (called Victory Villa). Since the war, much of the wartime housing has been demolished, but Aero Acres and Victory Villa remain distinct neighborhoods with aeronautical street names like Fuselage Avenue, Right (and Left) Wing Drives, and Taxi Way. (GLMMAM.)

Residence in wartime Middle River was limited to in-migrants from other states who had come to work at Martin. Concerned that these strangers might not get along, the federal government built community buildings for recreation and interaction. The Victory Villa Community Building, opened in 1942, remains virtually unchanged today. (GLMMAM.)

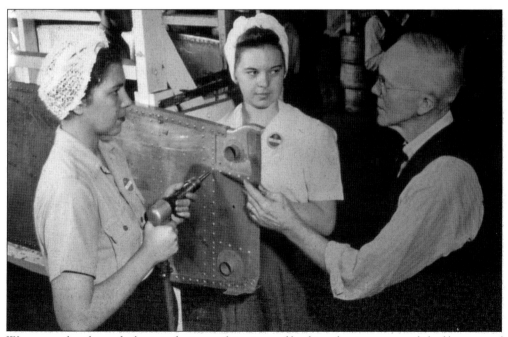

Women workers learn the basic techniques of riveting and bucking the rivet, accomplished by teams of two. Thousands of female workers joined the Martin workforce during the war. (GLMMAM.)

A would-be "Rosie the Riveter" learns about sensible shoes and appropriate clothing for factory work. Male Martin workers were called "Martineers" and female ones "Martinettes." The one-piece overalls were called—inevitably—"Martinalls." (GLMMAM.)

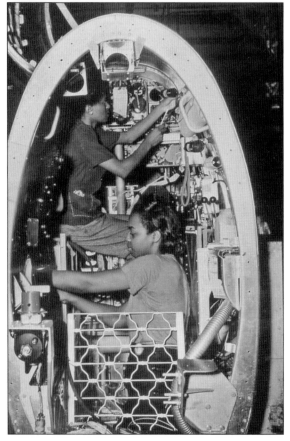

The Martin Company was initially opposed to hiring African American workers. Under federal regulations, black workers eventually could not be excluded. They numbered about 3,000, almost all of whom worked at a branch factory in the Canton district of Baltimore that manufactured subassemblies of the Baltimore bomber. The company also opposed unionization, but in 1943, the United Auto Workers won an election for union representation. (GLMMAM.)

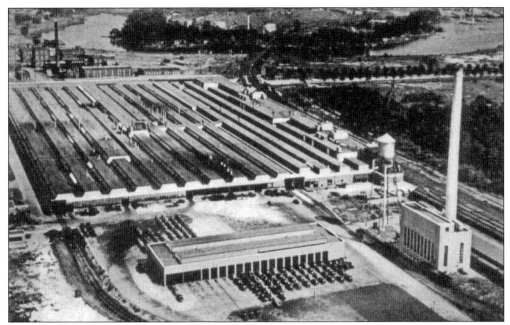

In 1942, the General Motors plant in Baltimore (also designed by the architect Albert Kahn) shifted from producing Chevrolets and Fisher Bodies to building aircraft. The Baltimore plant was part of Eastern Aircraft, a consortium of five eastern GM plants that produced two Grumman aircraft designs, the F4F Wildcat naval fighter (designated FM when built by GM) and the TBF Avenger torpedo bomber (TBM when built by GM). (GLMMAM.)

The Baltimore branch of the Eastern Aircraft concentrated on producing the rear half of the Avenger torpedo bomber and wing control surfaces. Finished tail sections were shipped to the Eastern Aircraft factory at Trenton, New Jersey, for final assembly and flight testing. (GLMMAM.)

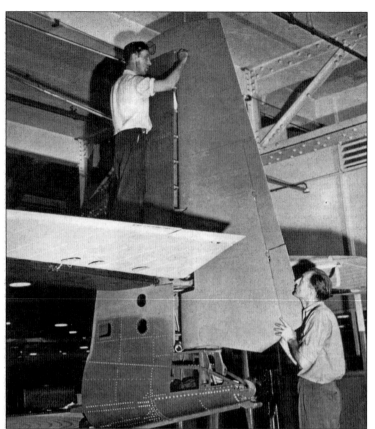

Workers at the Eastern Aircraft division of General Motors complete an Avenger tail assembly. (GLMMAM.)

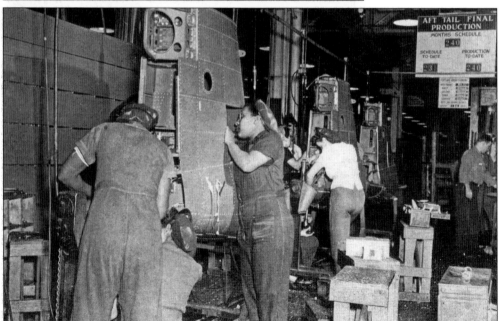

In contrast to Martin, Eastern Aircraft had a United Auto Workers contract to begin with and ran a racially integrated assembly line. (GLMMAM.)

Women workers at
Eastern Aircraft
sewed fabric control
surfaces. (GLMMAM.)

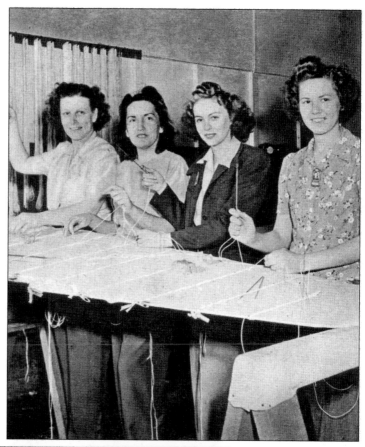

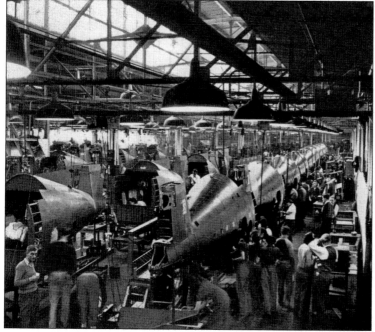

The skylit factory
floor at Eastern
Aircraft–Baltimore
is crowded as a
shift changes. Peak
employment reached
4,500 workers;
production efficiency
was among the
highest in the aircraft
industry. (GLMMAM.)

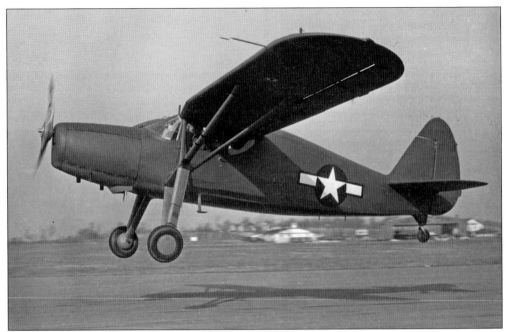

At Fairchild in Hagerstown, war orders were received for a military version of the Model 24 to be used as a light transport. More than a thousand were built in Hagerstown, designated the UC-61 and -81 Forwarder by the army, GK-1 by the navy, and Argus by the British Royal Air Force. This was in addition to mass production of PT-19 trainers. (WCHS.)

Fairchild subcontracted production to more than a score of converted factories. The "Hagerstown Plan" reduced the need for new factory construction and, by employing local residents, reduced the need for in-migrant workers. Of course, this system would work only for fairly small planes like the PT-19 and UC-61. (WCHS.)

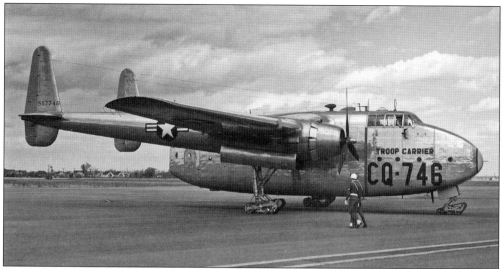

By the time production of PT-19s ended in April 1944, Fairchild had orders for a very different design: a military cargo plane designed around a 2,870-cubic-foot cargo container, the same size as a standard railway boxcar. Officially designated the C-82 Packet, the plane acquired the nickname "Flying Boxcar." Fairchild built 224 C-82s between 1944 and 1948; one is preserved at the Hagerstown Aviation Museum. Shown here is a C-82 with experimental tracked landing gear. (DO.)

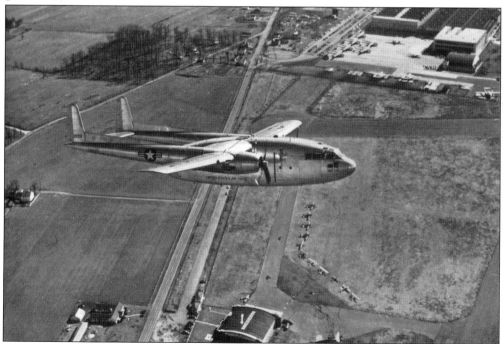

After the war, an improved version of the C-82 was officially designated the C-119 Flying Boxcar. It had larger engines; longer wings; a lower, more forward position for the cockpit; and a somewhat larger cargo compartment than its predecessor. Fairchild built 1,114 Flying Boxcars (97 of them marine R4Qs) between 1947 and 1968; another 71 were built by subcontractor Kaiser-Frazer in Michigan. (HAM.)

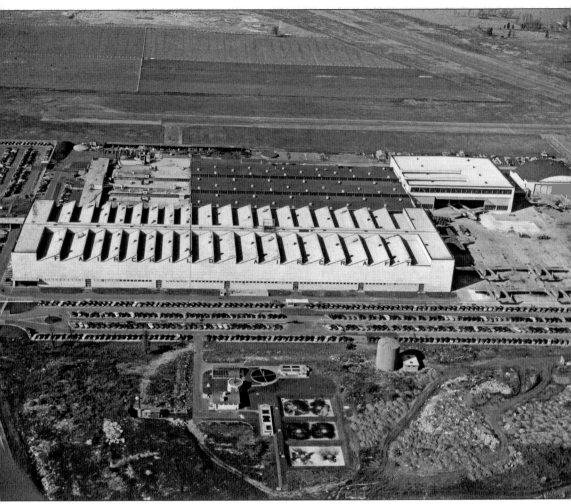

Fairchild's Plant No. 2 began operations in 1941 on a site leased from the Hagerstown Airport. During the war, several additions were built, including a vaulted hangar designed by Albert Kahn and a large assembly hall for C-82s lit by sawtooth roof monitors. Several C-82s are visible on the aprons adjoining the factory. (WCHS.)

The ERCO factory in Riverdale had also expanded in size during World War II. After 1945, the company went into full production of Ercoupes, eventually turning out 5,140 planes—the largest production of any aircraft type built in Maryland. An early-model Ercoupe hangs from the ceiling of the Smithsonian Air and Space Museum's Udvar-Hazy Center. (CPAM.)

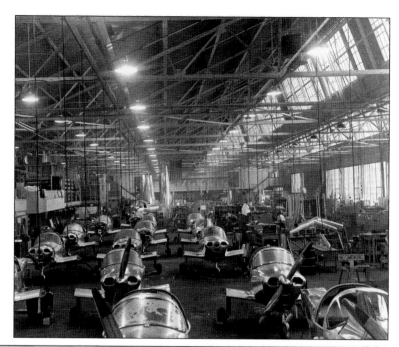

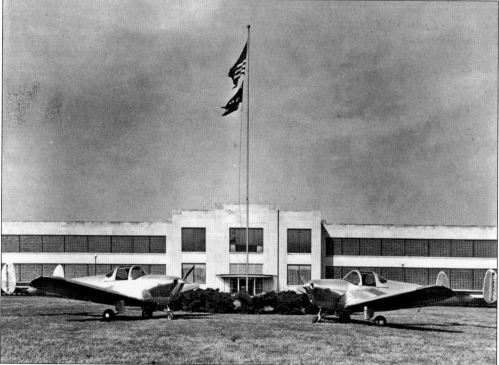

The market for general-aviation planes did not prove to be as large as ERCO had hoped. Production of the Ercoupe in Riverdale ended in early 1952, though the design continued to be manufactured elsewhere into the 1970s, some marketed under the name Aircoupe. The Riverdale plant turned to making school bus bodies and flight simulators. Eventually the company airfield was sold off and the plant converted for office use. (CPAM.)

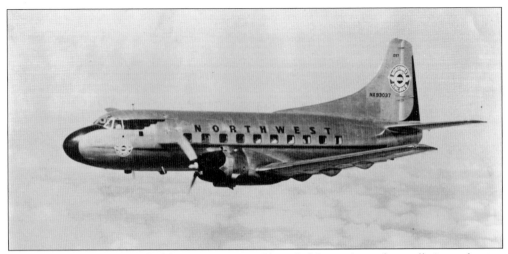

The late 1940s were a period of disappointment at Glenn L. Martin Aircraft as well. As production of warplanes ran down in 1944, Martin engineers came up with a number of new designs. Most promising was a commercial airliner, the 202. With two powerful piston engines, it could carry 40 passengers on short routes, as many seats as on a four-engine DC-4. (GLMMAM.)

Martin hoped to offer the first new designs to equip the postwar airline fleets, but the 202 went into service in 1947 with a structural flaw in the wings that led to the fatal crash of a Northwest Airlines 202. Except for Northwest and a few small South American airlines, orders dried up. Most airlines instead purchased Convair 240-series planes similar in appearance to the 202. (GLMMAM.)

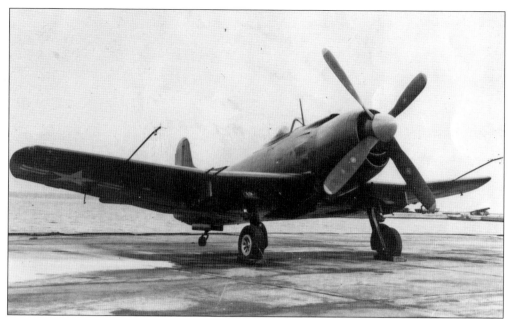

Another of the 1944 Martin design projects was the massive AM-1 Mauler carrier bomber for the navy. Although the Mauler was able to lift record bombloads, it had a poor maintenance record. The navy only purchased 149 of the planes between 1947 and 1949, preferring the long-serving Douglas AD-1 Skyraider. Several Maulers survive in museums, including the Naval Aviation Museum in Pensacola. (PRNAM.)

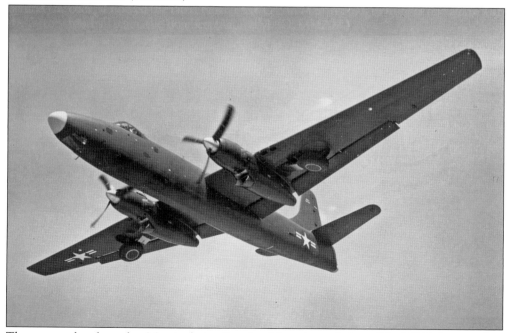

The navy ordered another Martin design for a land-based patrol plane. The P4M Mercator, first rolled out in 1946, was powered by two conventional piston engines and two jets in the same nacelles. Although the navy purchased 21 planes, the Martin design again lost out to a competitor, in this case the Lockheed P2V Neptune. (GLMMAM.)

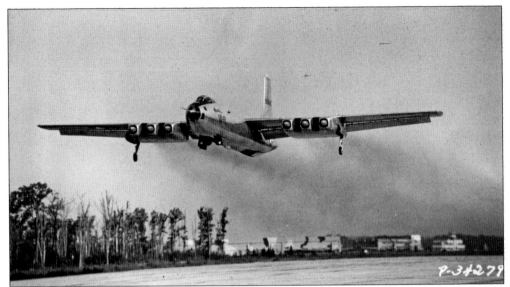

Martin also built a prototype all-jet medium bomber for the U.S. Air Force, the XB-48. At its first flight in June 1947, neighbors of the Martin airport, unaccustomed to the smoky plumes of jet engines, called police to report an aircraft on fire. The technologically advanced, swept-wing Boeing B-47 won an air force competition for a new bomber for the Strategic Air Command. Only two XB-48s were built. (GLMMAM.)

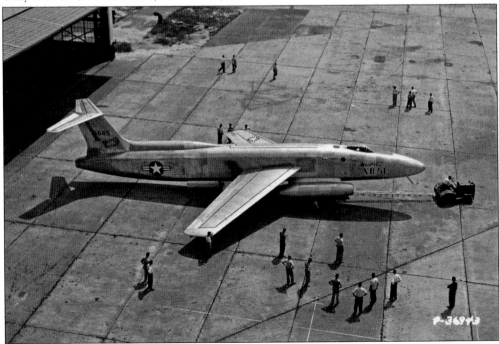

Having lost out on the XB-48's conventional design, Martin engineers went to the other extreme with the prototype XB-51, here rolled out in 1949. It featured variable-incidence swept wings, a T tail, and a revolving internal bomb bay. Although the two prototypes ordered by the U.S. Air Force performed well, they were not well suited to ground-support needs in the Korean War, which had broken out in June 1950. (GLMMAM.)

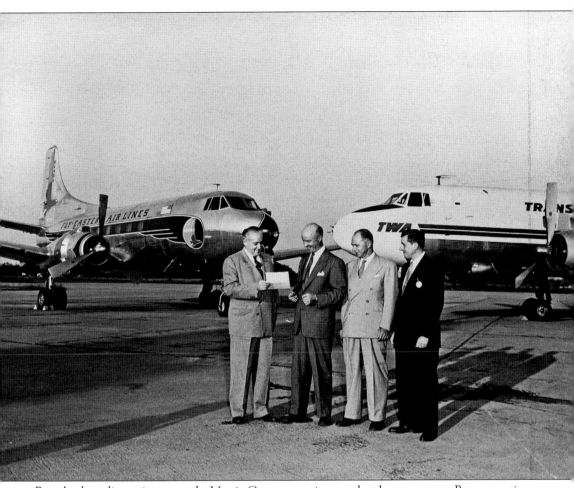

Beset by these disappointments, the Martin Company again turned to the government Reconstruction Finance Corporation for financing. Bankers insisted on the ouster of Glenn L. Martin from management. The company's new executives signed a complex deal with Eddie Rickenbacker of Eastern Airlines and Howard Hughes of Trans World (TWA) in 1950 for an improved version of the 202, the Martin 404. Each airline ordered 50; in addition, TWA leased thirteen 202As assembled from stock parts. The number of planes was still insufficient for a profit, but the sturdy pressurized-cabin 404s served for decades. Several are preserved in museums, including the Glenn L. Martin Maryland Aviation Museum. (GLMMAM.)

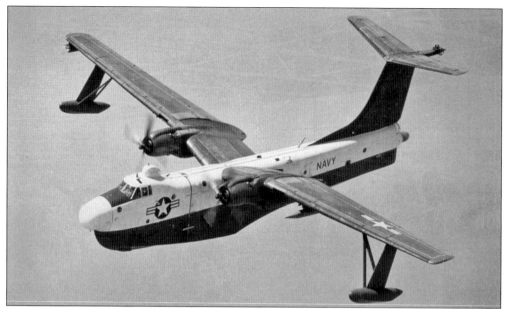

The only one of Martin's late 1940s designs to profit the company was the P5M antisubmarine flying boat, a further development of the PBM. The navy purchased 287 P5M Marlins between 1949 and 1960. A partially restored P5M is part of the collection of the National Museum of Naval Aviation in Pensacola. (GLMMAM.)

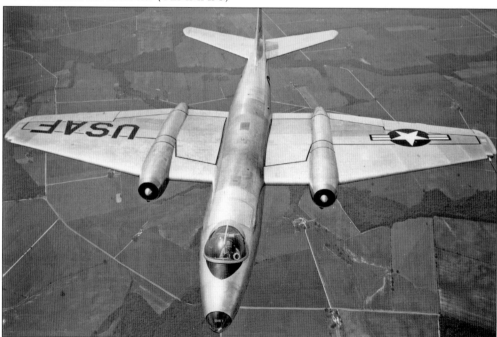

The plane that returned Martin to prosperity during the 1950s was not a Martin design. In 1951, a U.S. Air Force competition for a ground-support bomber for the Korean War chose the Canberra jet bomber built by English Electric Ltd. Since the British plant was fully committed to Royal Air Force orders, Martin built 75 planes under license, designated B-57A by the U.S. Air Force. Two are on display at the Glenn L. Martin Maryland Aviation Museum. (GLMMAM.)

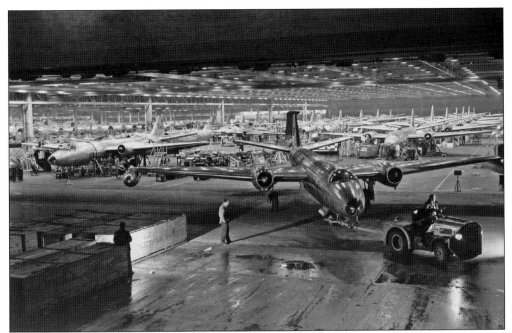

Martin's Plant No. 2, which had reverted to government ownership in 1945, was reopened to build B-57s. Even so, deliveries did not start until after the Korean War had ended. In service, the B-57s were used more for bombing and reconnaissance than for ground support. After its use to build B-57s, Plant No. 2 served as a government warehouse; in 2007, in vintage condition, it was sold to private developers. (GLMMAM.)

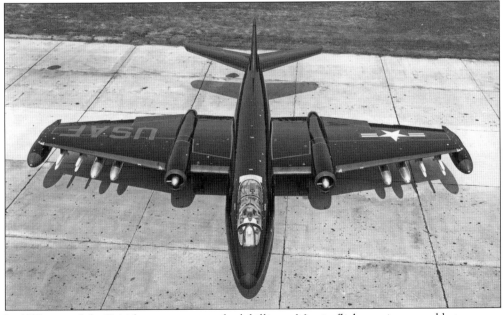

In 1951, one of the British prototypes crashed, killing a Martin flight engineer unable to escape from the bombardier's seat inside the fuselage. Martin redesigned the plane, moving crew positions into a large teardrop canopy with ejection seats; 328 planes were built as Martin B57-B, C, D, and E models. (GLMMAM.)

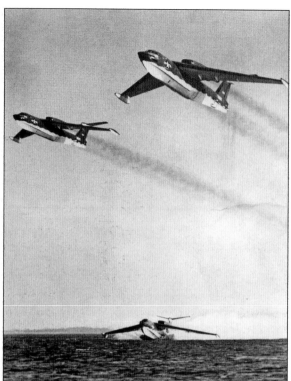

In 1951, the U.S. Navy commissioned Martin to design a large jet-powered flying boat. The ostensible purpose was as a minelayer, but the real purpose was to provide the navy with a strategic nuclear bomber capable of being launched from the oceans of the world. Martin's design was the graceful XP6M SeaMaster. (PRNAM.)

Two test crashes delayed the development of the SeaMaster. The navy turned to submarine-launched ballistic missiles instead and cancelled the whole program in 1959. All 16 aircraft built were broken up. This proved to be Martin's last production aircraft project in Maryland. Merged with the Marietta Corporation and later with Lockheed, the Martin name nevertheless continues to appear on aircraft and missiles, and Lockheed Martin's corporate headquarters is in Bethesda. (GLMMAM.)

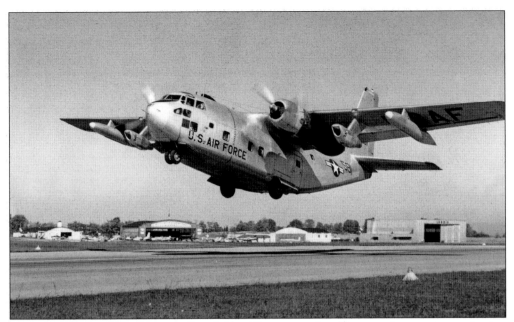

The 1950s were a prosperous era for Fairchild in Hagerstown. In addition to the ongoing production of the C-119, the company received an order for a tactical transport, the C-123 Provider. Developed from a glider design, the C-123 was intended to land on short fields near the front lines. In addition to two piston engines, the planes also mounted small jets. The U.S. Air Force ordered 300. (HAM.)

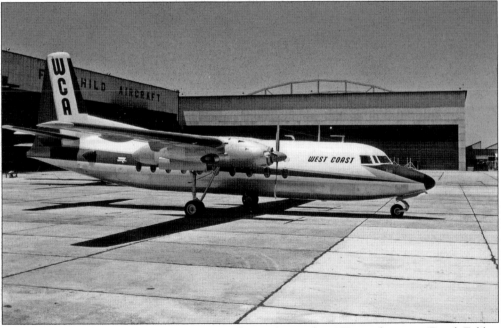

Like Martin, Fairchild also produced a foreign design during the 1950s, in this case a Dutch Fokker turboprop airliner, the F-27. Fairchild engineers spent two years translating dimensions from metric to English measures. The F-27 began service with West Coast Airlines in 1958, the first turboprop airliner to go into service in the United States; 129 were built from 1958 to 1968. (HAM.)

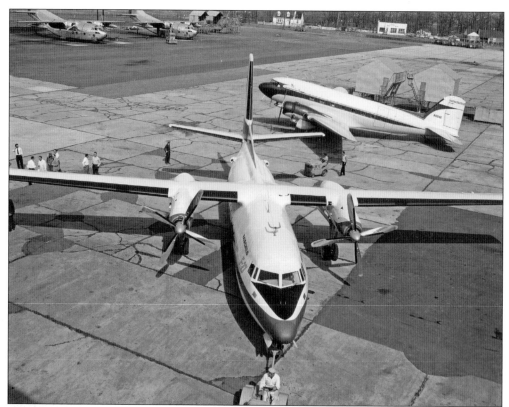

The F-27 was touted as the replacement for the venerable DC-3, still in service on many regional airlines in the 1960s. (HAM.)

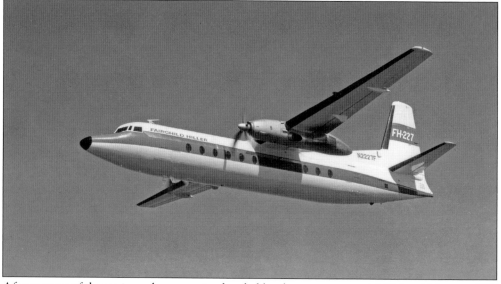

After a successful opening sales campaign headed by the entrepreneurial Richard Henson, F-27 sales fell off in the early 1960s. Adding six feet to the fuselage provided 12 extra passenger seats for the FH-227, 78 of which were produced between 1966 and 1968. The new initials represented Sherman Fairchild's purchase of Hiller Aircraft in 1964. (HAM.)

Fairchild's Plant No. 2 at the Hagerstown Airport was extended in the 1950s by an addition supported by arched trusses. Visible here are new camouflaged C-123s and a variety of airliners traded in on F-27s. Another new plant, on the southwest corner of the airport, contained autoclaves for bonded structures used extensively in the F-27. Since the end of aircraft manufacture in 1984, Plant No. 2—now known as the Top Flight Air Park—has housed a number of enterprises. (HAM.)

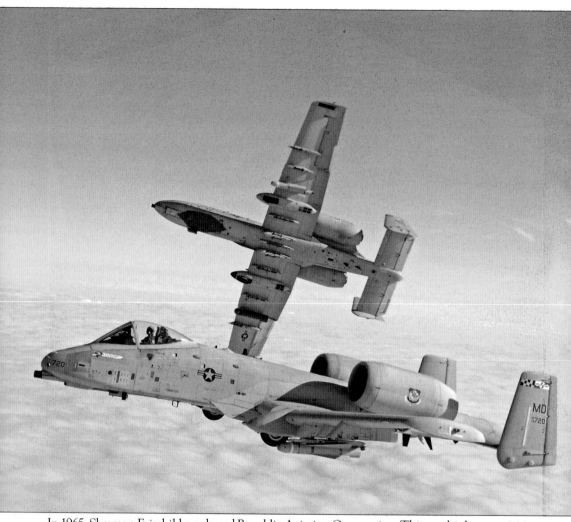

In 1965, Sherman Fairchild purchased Republic Aviation Corporation. This was his last acquisition; he died in 1971. In 1974, the company won a competition for a new ground-support aircraft for the U.S. Air Force. The twin-jet A-10 carried an impressive array of ordnance, but it was not sleek or beautiful. Officially designated the Thunderbolt II in memory of the Republic-built fighter of World War II, the A-10 received the nickname of "Warthog." The Republic plant in Farmingdale, New York, built fuselages, but final assembly took place at Hagerstown. Between 1973 and 1984, 715 were built, the last manned aircraft to be mass produced in Maryland. (MANG.)

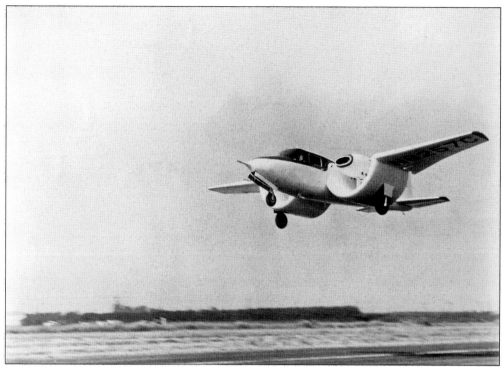

The inventor Willard Custer designed an aircraft that derived lift from airflow generated by engines mounted in a wing channel. In 1964, the Custer Channel Wing Corporation, based in Hagerstown, flew a prototype that promised helicopter-like performance, but the corporation collapsed in a stock-market scandal. Two CCW-5s are preserved at the National Air and Space Museum and the Mid-Atlantic Air Museum in Reading, Pennsylvania. (DO.)

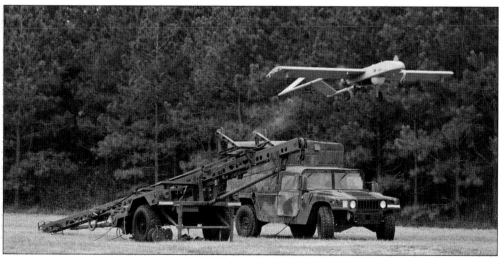

Aircraft production in Maryland continues in the Shadow line of unmanned reconnaissance aircraft, a trademark of AAI Corporation of Hunt Valley. Launched from an army truck, the 375-pound Shadow 200 can stay aloft over a battlefield for five to seven hours. An even larger unmanned plane is projected by American Dynamic Flight Systems of Jessup. With a payload of 500 pounds, it could remove casualties as well as carry sensors or weapons. (AAI Corporation.)

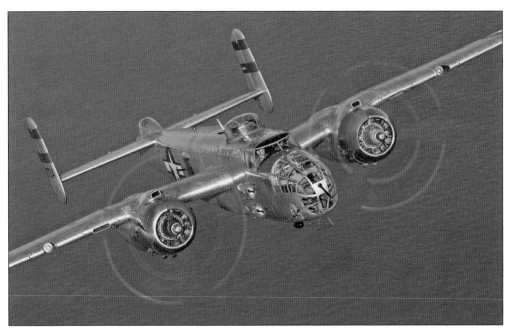

Those who restore or reconstruct older aircraft also belong among Maryland's aircraft builders. Here Larry Kelley of Salisbury flies his restored World War II B-25 bomber, *Panchito*. (Larry Kelley.)

In addition to teaching "the art of tailwheel flying" at his own airstrip at Marydel, Maryland, Tony Markl specializes in working with aircraft fabrics. Here he is at work on the control surfaces of a Pitts biplane. (Tony Markl.)

Three

FLYING FIELDS
AND AIRPORTS

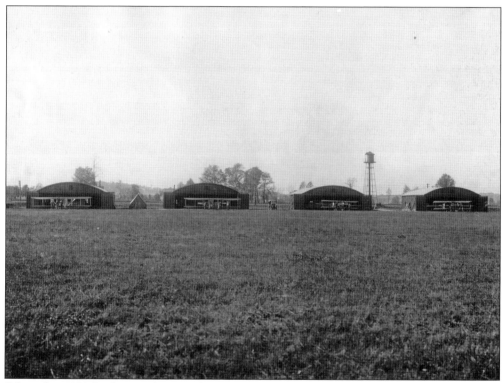

Selected in 1909 for the Wrights' air school, College Park is the world's oldest airport. The original grass flying field is visible in front of four hangars erected in 1911. By this time, the U.S. Signal Corps was buying both Wright aircraft, controlled in the air by wing-warping (left hangars), and Curtiss planes, steered by means of ailerons (right hangars). (CPAM.)

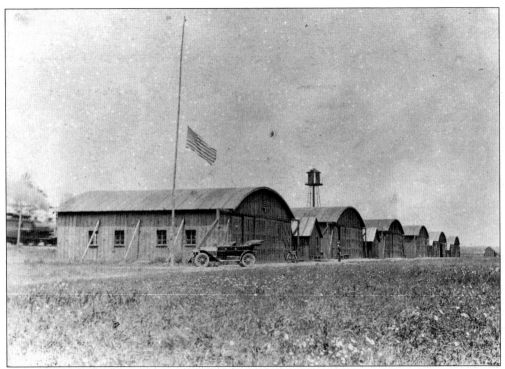

The American flag flies at half-staff alongside the row of hangars at the Army Aviation School at College Park. It probably mourned the death in May 1912 of aviation pioneer Wilbur Wright. He died in Dayton, Ohio, after a bout with typhoid fever. (CPAM.)

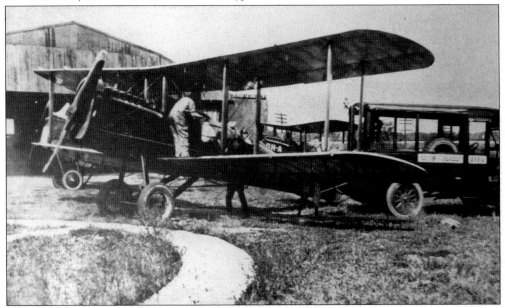

The first airmail service in the United States began at College Park in early 1918, flying from Washington to New York using army pilots. In August, the U.S. Post Office took over the service with its own pilots, based at a new hangar at College Park. Here a war-surplus DH-4 mail plane is readied for flight in front of the post office hangar. (CPAM)

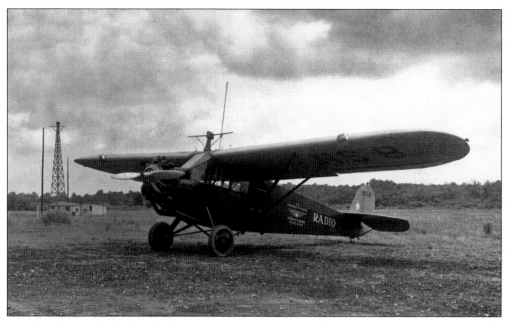

Another first for the College Park Airport was an instrument landing system. Experimental radio antennas were erected by the U.S. Bureau of Standards in 1927. On September 5, 1931, Marshall S. Boggs made the first successful blind landing based only on a radio landing beam system. Shown here is a Fairchild FC-2W equipped with an early instrument landing system beside the Bureau of Standards tower. (CPAM.)

In 1988, the College Park Aviation Museum opened its doors. Displays inside illustrate the history of the first airport from the time of the Wright brothers to the present. Both the museum and the airport are operated by the Maryland–National Capital Park and Planning Commission. (CPAM.)

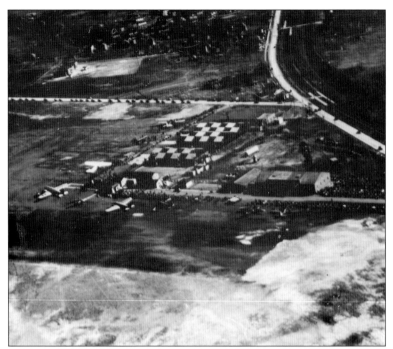

In 1919, the first Baltimore flying field was established on Bethlehem Steel Company land in Dundalk. In the following year, it was named after an army stunt pilot killed at an air show there. Like other early airports, Logan Field was just that—a level turf field of about 100 acres on which airplanes landed against the wind, whichever way it was blowing. (DPNHS.)

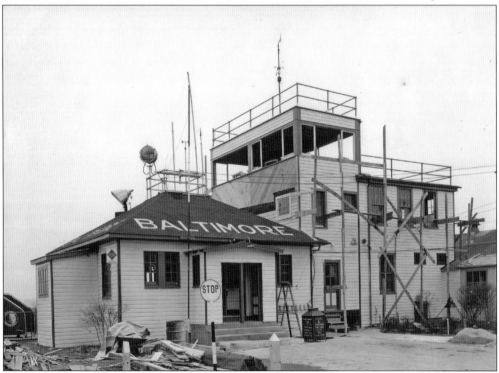

Maryland's first airport terminal was erected at Logan Field in the 1920s. A modest structure compared to contemporary railroad terminals, it contained airline offices and ticket windows, a passenger waiting room, and a "tower"—for observation of ground traffic and a site for the simple meteorological instruments of the day. (DPNHS.)

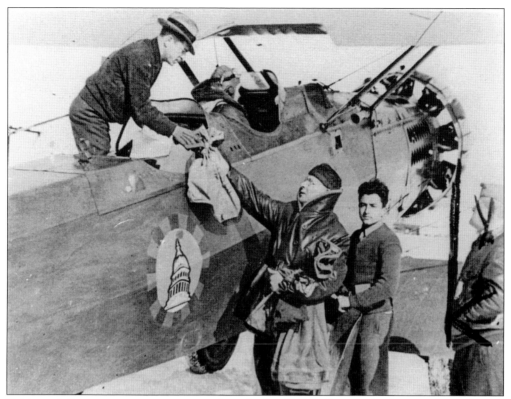

Baltimore's first passenger air service was launched in 1930 by Eastern Air Service. Airmail came later, in February 1934. Here the first northbound Mailwing aircraft to land at Logan Field is loaded with mail for Philadelphia and New York. (DPNHS.)

In 1923, the U.S. Army leased Mexico Farms south of Cumberland as a stop on a model airway for army planes flying between Washington and Wright Field near Dayton. This innovative wire-supported hangar was one of the first buildings erected. (MHT.)

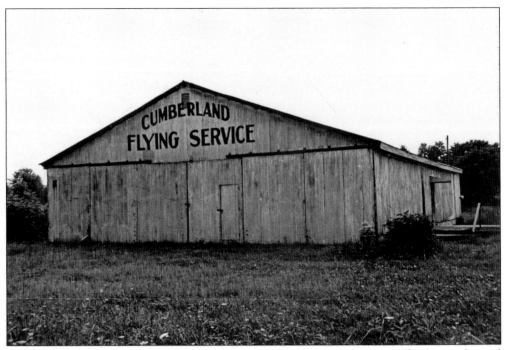

Eventually, private aviation replaced army activity at Mexico Farms Airport. This hangar housed the "fixed base operator" (FBO) that provides fuel and other services at every airport. (MHT.)

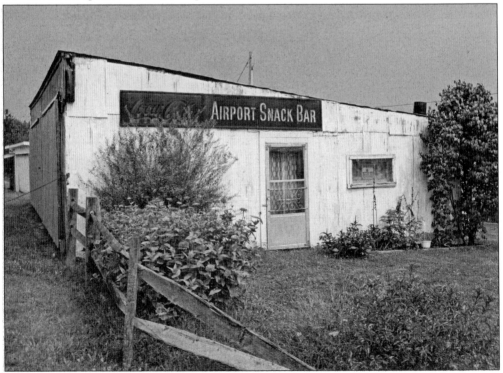

Another airport institution is the snack bar. This one at Mexico Farms fed Charles Lindbergh, Jimmy Doolittle, Wiley Post, and other less famous flyers over the years. (MAA.)

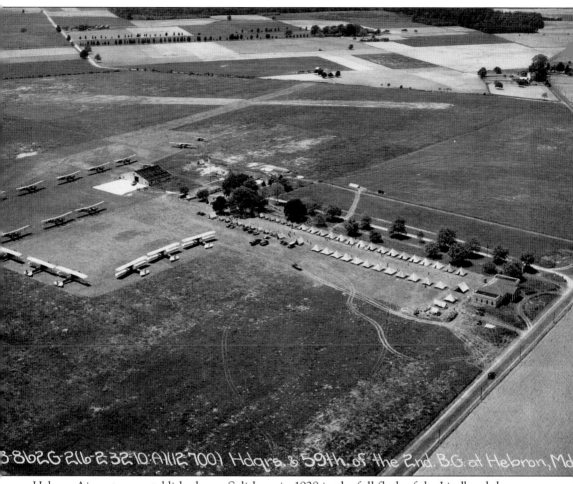

3-862-G-216-2-32:10-A(12-700) Hdqrs. & 59th. of the 2nd. B.G. at Hebron, Md

Hebron Airport was established near Salisbury in 1928 in the full flush of the Lindbergh boom. An ambitious scheme, the airport boasted a large hangar (top left), a columned clubhouse (center right), and a turf runway 1 3/8 mile long. It closed amidst legal wrangles in March 1930, though the Army Air Corps' 2nd Bombardment Group apparently rented the field for their summer exercises in June 1932, the date of this photograph showing their Keystone bombers and tented camp. (DPNHS.)

Another Lindbergh boom airport was established in the countryside north of Hagerstown by the Kreider-Reisner (later Fairchild) Aircraft Company. Here a Fairchild Model 22 comes in to land in the early 1930s. At left is the lunch stand that developed into the Airport Inn restaurant; the shack at right belonged to the Henson Flying Service, progenitor of numerous Henson enterprises. (HAM.)

In 1934, the City of Hagerstown purchased the airport to forestall Fairchild's threatened move to Florida. The city added 21 acres, two paved runways, and this handsome brick hangar. A Cessna T-50 Bobcat is parked outside. (HAM.)

The nerve center of the Hagerstown Airport was the Henson Air Services operation center. (HAM.)

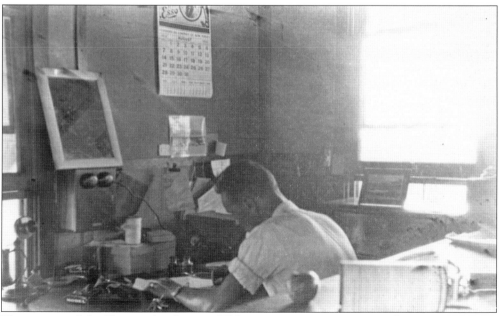

The interior of the Henson Air Services FBO operations center is pictured in August 1932. A telephone seems to be the most advanced communications device. (HAM.)

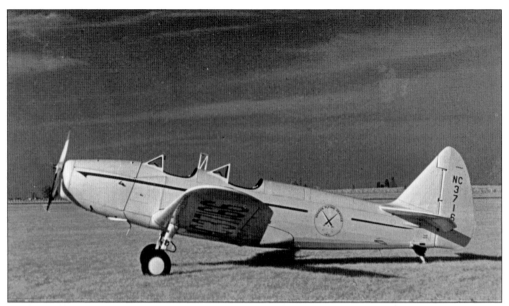

In 1939, the federal government launched the Civilian Pilot Training Program (CPTP) to produce more pilots for national defense. Richard Henson set up a CPTP school using a local product, Fairchild's PT-19 trainers, painted all yellow with Henson's insignia. (HAM.)

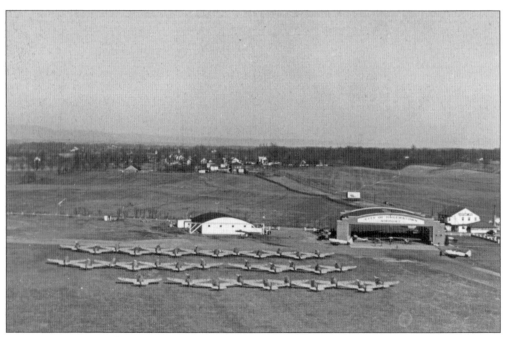

Henson's CPTP was based at the Municipal Hangar at Hagerstown Airport. Besides Fairchild PT-19s, his equipment included Piper J-3 Cubs. (HAM.)

Highways leading north from Hagerstown had to accommodate the extension of the airport's principal east-west runway. This aerial view shows Interstate 81 and U.S. Route 11 both curving around the Hagerstown Regional Airport, also known since 2001 as Richard A. Henson Field. (MAA.)

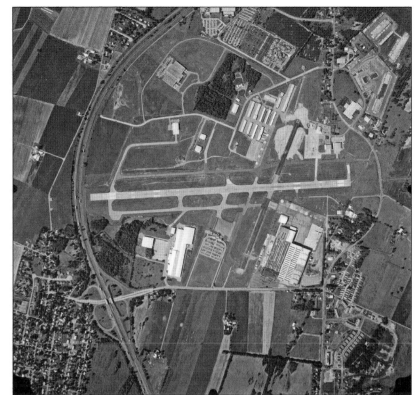

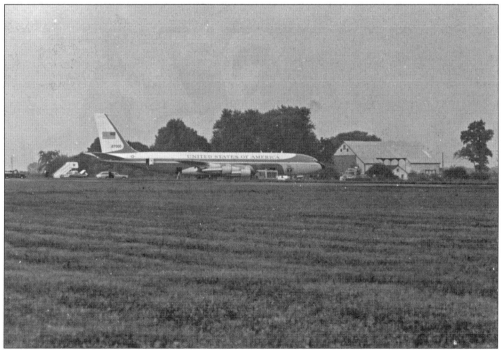

A special apron at Henson Field plays host to Air Force One and other national command aircraft when the president is in residence at nearby Camp David. (HAM.)

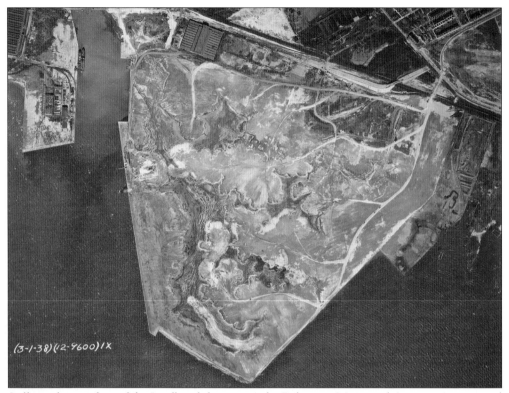

(3-1-38)(12-9600)1X

Still another product of the Lindbergh boom was the Baltimore Municipal Airport. Announced in 1928 and begun in 1929, it was built on 360 acres of landfill in Baltimore Harbor. The harbor dredge spoil used as fill, however, refused to dry and solidify properly. This aerial photograph dates from 1938; work was proceeding under the WPA, but the airport was still incomplete. Though obsolete, nearby Logan Field remained in use. (DPNHS.)

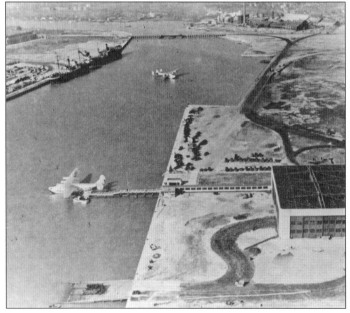

The first part of Baltimore Municipal Airport to go into service was the seaplane base on the west side of the bulkheaded site. One Boeing 314 clipper is docked at Pan American Airways' art deco hangar and terminal; another is anchored in Colgate Creek. Pan Am service to Bermuda began in 1937. Beginning in 1941, the British Overseas Airline Corporation used this base as the terminal for their transatlantic service, using Boeing 314s. One of the wartime passengers was Winston Churchill. (DPNHS.)

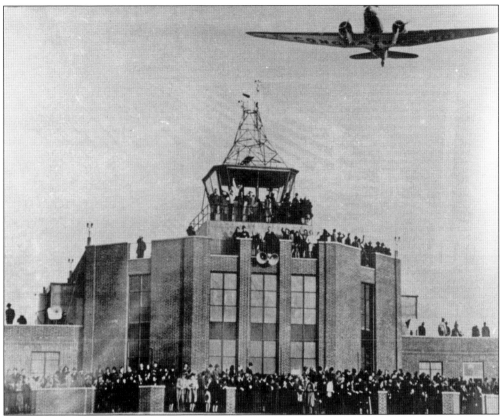

Opening day for the Baltimore Municipal Airport came at last on November 16, 1941. Despite its handsome art deco terminal, the airport's 3,000-foot runways were already obsolete. Renamed Harbor Field, it was downgraded to a general aviation airport in 1950. Today it is the site of the Dundalk Marine Terminal. (DPNHS.)

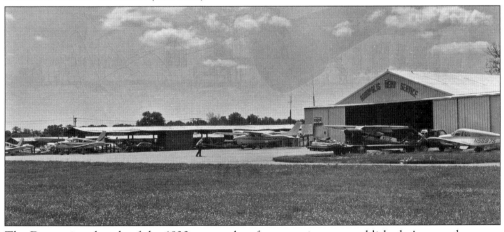

The Depression decade of the 1930s saw only a few new airports established. Among them was Lee Field near Annapolis, which dates from 1939–1940. Frequently on the brink of closing, Lee achieved some stability when the Harbor Field FBO moved there in the early 1960s, changing its name to Annapolis Aero Services (depicted here). Lee is the only airport in the immediate vicinity of Maryland's capital city. (MAA.)

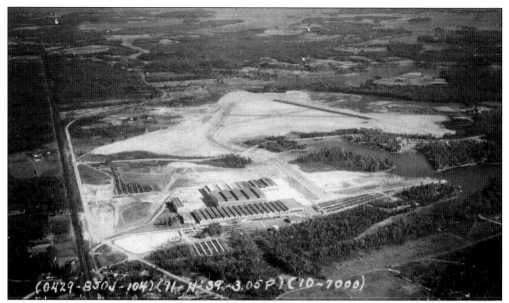

World War II led to a number of large new airports in Maryland. In 1939, the expansion of the Glenn L. Martin aircraft plant obliterated the original factory airfield. A new airport was constructed on a much larger scale north of the factory on the Strawberry Point peninsula. It is at this point that paved runways began to supplant grassy flying fields. (GLMMAM.)

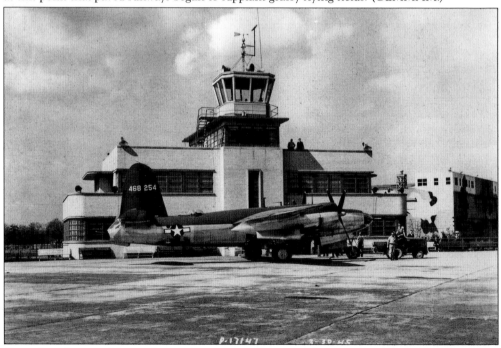

Central to the new Martin Airport was a magnificent art deco terminal building designed by Albert Kahn, flanked by three giant hangars on either side. All remain in use today; Hangar 5 is the home of the Glenn L. Martin Maryland Aviation Museum. In this photograph, the last of the 4,056 B-26s manufactured in Maryland stands in front of the terminal in March 1945. (GLMMAM.)

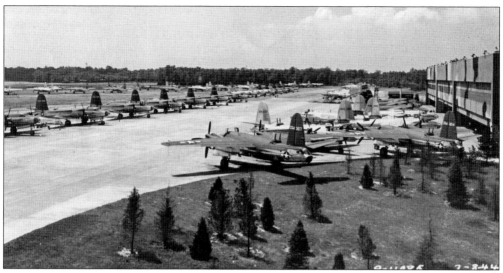

Two rows of newly built B-26s are lined up in front of the Martin Airport hangars. Every plane required several test flights, often leading to repairs or adjustments—making the factory airport a busy place. The trees planted around the apron were part of an elaborate wartime camouflage scheme. (GLMMAM.)

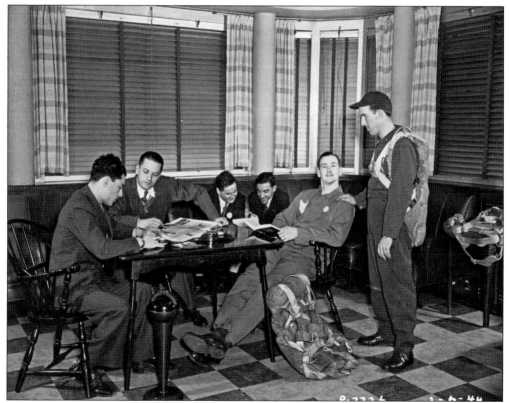

The Martin Airport terminal housed a rooftop control tower, the headquarters for the flight-test department, a cafeteria, and a waiting room for test and ferry pilots, shown here in 1944. (GLMMAM.)

The Martin Airport was separated from the Martin plants by Wilson Point Road and Eastern Boulevard, making it necessary for land planes to cross the street to begin flight testing. Here Martin guards stop traffic on Eastern Boulevard to trundle a new B-26 from Plant No. 2 to the airport. (GLMMAM.)

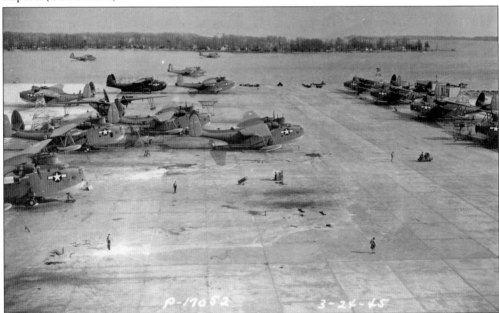

Martin's seaplanes could avoid the street crossings by taxiing down Middle River to the factory's seaplane base on the tip of Strawberry Point. Here, in 1945, 14 PBM-5s await test flights, along with a single dark-blue PBM-3R cargo version. Today the large apron contains the headquarters of the Maryland emergency helicopter system and also the historic aircraft collection of the Glenn L. Martin Maryland Aviation Museum. (GLMMAM.)

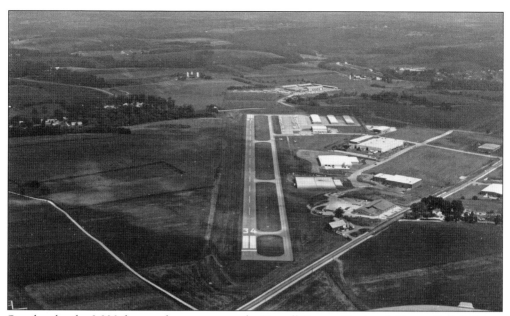

Sun dapples the 2,930-foot modern runway at the Carroll County Regional Airport/Jack B. Poage Field north of Westminster. Originally built by the men and women of the Baltimore Wing of the Civil Air Patrol as their wartime base, the field was purchased by the county in 1976. Poage, longtime FBO at the field, was killed in an air show accident in 1990. (MAA.)

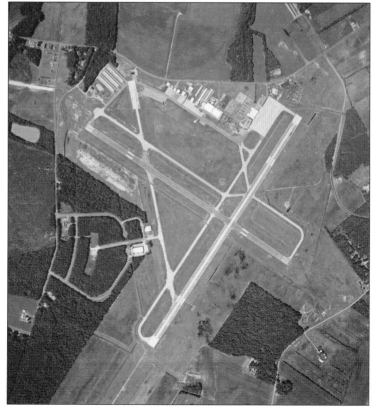

A national defense plan formulated in 1940 by the Civil Aeronautics Administration called for a large airport in the Salisbury area of the Eastern Shore. Using WPA labor, the city of Salisbury completed a new airport (now the Wicomico Regional Airport) in 1943. Here again, paved runways aligned to prevailing wind directions have replaced turf flying fields. (MAA.)

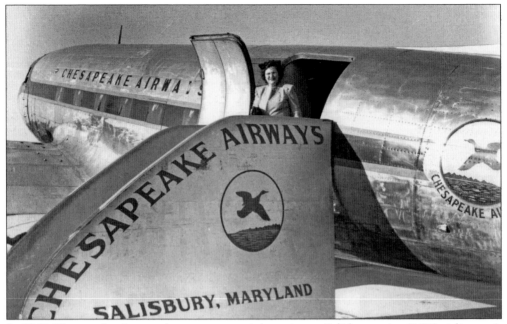

In 1947, Chesapeake Airways began commercial service to Salisbury using DC-3 airliners. A number of other regional airlines followed; eventually Richard Henson moved the base for his commuter airline from Hagerstown to Salisbury. (AACHS.)

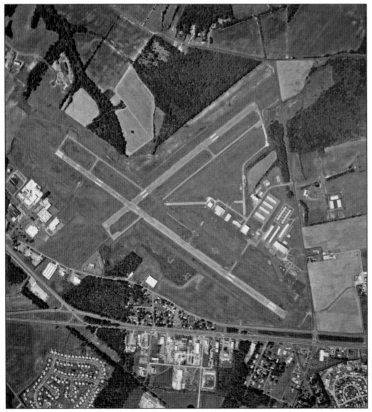

Federal authorities paid for another Eastern Shore airport at Easton, probably as an overflow/emergency field for the navy's Patuxent River base (see next section). After the war, the Town of Easton took charge of a 582-acre airport with two 4,000-foot runways. Locals joked that it was bigger than the town. (MAA.)

William (Bill) Newman managed the Easton Airport between the 1960s and 1980s and also operated Maryland Airlines, an air-taxi service to National Airport in Washington. Today the field also bears his name. In 1987, a new terminal was added, setting the pattern for similar new terminals at Hagerstown and Cumberland. (MAA.)

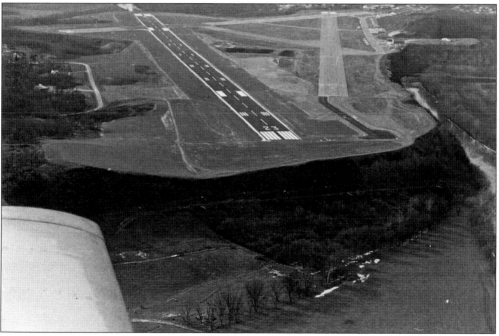

Judging that the field at Mexico Farms was inadequate for an airport to serve the Cumberland area, federal and local authorities constructed a new facility during the 1940s atop Knobley Mountain in Wiley Ford, West Virginia. It is a difficult site; one of the field's runways ends in a bluff over the Potomac River. Today Greater Cumberland Regional Airport is run by a bistate authority. (MAA.)

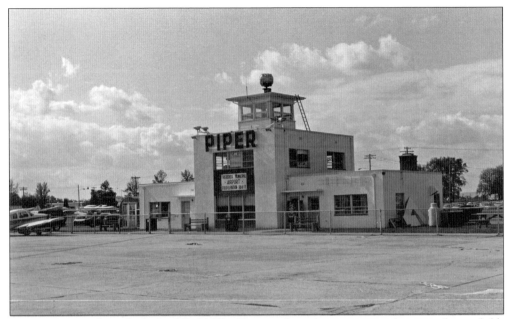

Private aviation flourished after World War II, not only at the new regional airports but at fields developed specifically for general aviation. Depicted here is the control tower of the Frederick Municipal Airport, opened in 1946 after Fort Detrick had absorbed an earlier field. (MAA.)

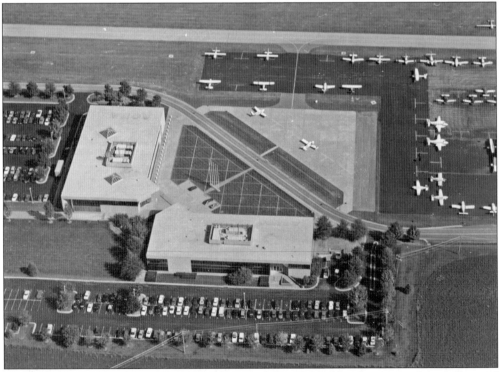

Frederick Airport was chosen in 1982 as the site of the national headquarters of the influential Aircraft Owners and Pilots Association (AOPA). Boasting runways 5,220 and 3,800 feet long, Frederick is among the busiest general aviation airports in Maryland. (MAA.)

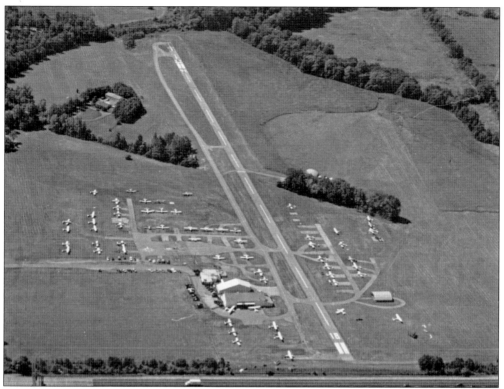

Other postwar general aviation fields were much smaller, like Freeway Airport, established in 1947. Located alongside Route 50 near Bowie, it has a single 2,150-foot paved runway. (MAA.)

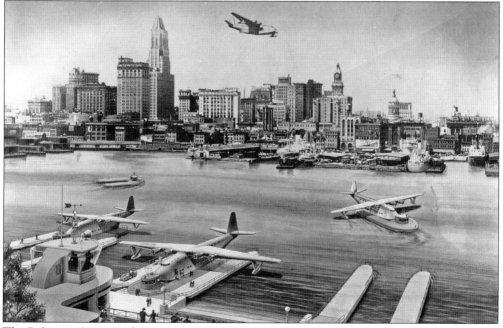

The Baltimore Municipal Airport at Dundalk was never a success. In 1945, manufacturer Glenn L. Martin suggested a flying-boat airport in Baltimore's Inner Harbor. (GLMMAM.)

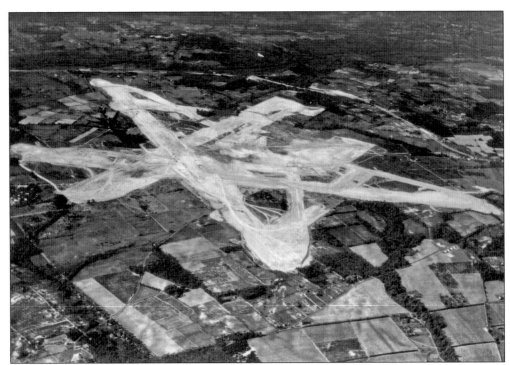

Instead of a downtown airport, the city's leaders opted for a regional one, purchasing 3,170 acres at Friendship in Anne Arundel County adjoining the new parkway between Baltimore and Washington. The three principal runways and taxiways (shown under construction in 1947) formed a star-shaped pattern. (MAA.)

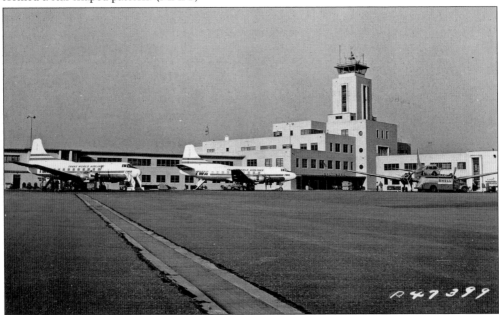

The terminal at the new Friendship Airport, designed by the Baltimore architect James Edmunds, featured a towering 110-foot art moderne control tower. Finger buildings led passengers out to departure gates, here serving new Martin 202A and 202 airliners. (GLMMAM.)

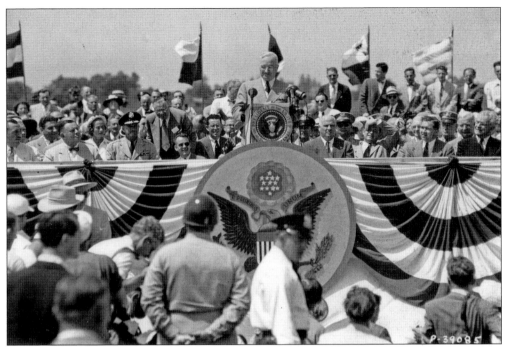

Pres. Harry Truman gave the dedication speech opening the airport on June 24, 1950. He was reportedly disappointed by the size of the crowd and by the broiling heat on the tarmac. Worse was yet ahead—later that day, the Korean War broke out. (GLMMAM.)

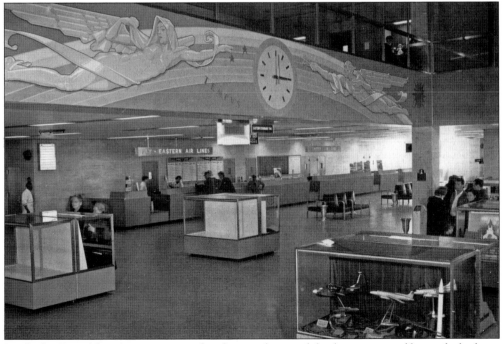

Inside the Friendship Airport terminal, ticket windows and display cases stand beneath the large clock and bas-relief "tempus fugit." Not many passengers crowd the picture however, a chronic problem in Friendship's first two decades. (GLMMAM.)

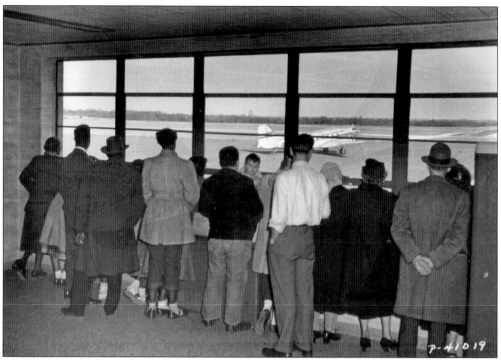

The observation deck at Friendship Airport in 1950 was crowded, but baggage claim was a breeze! (GLMMAM.)

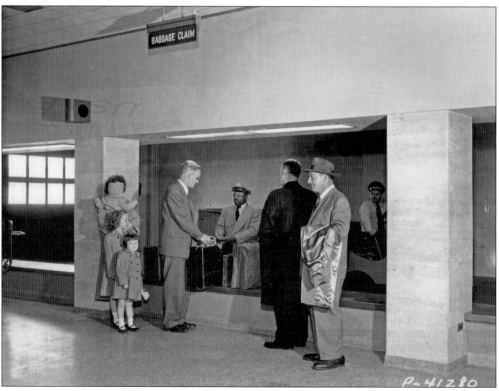

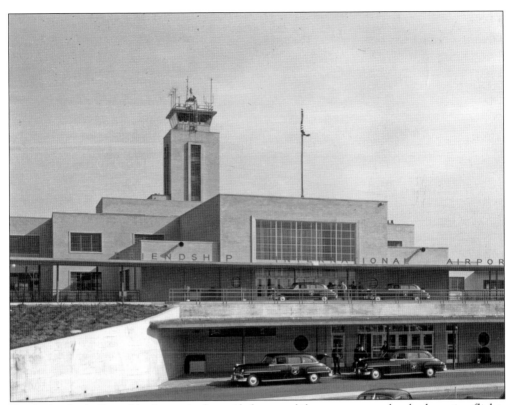

On the land side, Friendship's terminal provided automobile access on two levels: departing flights above and arrivals below. (GLMMAM.)

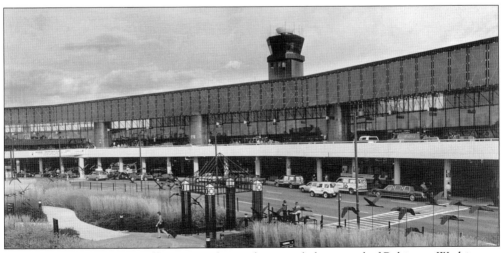

The same arrangement is still in use in the vastly expanded terminal of Baltimore-Washington Thurgood Marshall International. In 1972, the State of Maryland purchased the airport from the City of Baltimore and began an ongoing series of improvements and expansions. (MAA.)

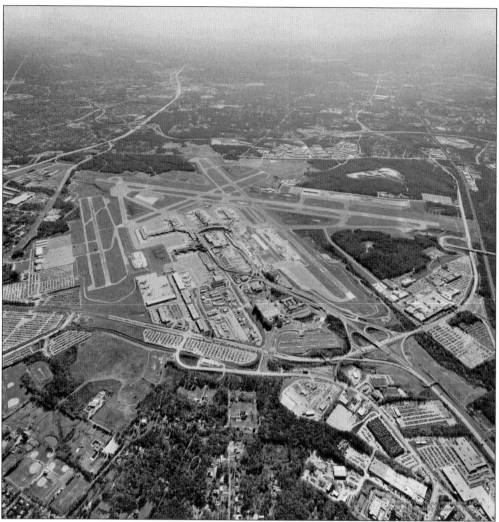

Baltimore-Washington International's original star pattern still involves inconvenient runway crossings, but a new parallel runway (left side of photograph) points to future developments. So does the conglomeration of roads and commercial and industrial establishments crowding around the busy airport. (MAA.)

A pattern of development similar to Baltimore-Washington International's is seen around the Montgomery County Airpark, established near Gaithersburg in 1960 as part of a light industrial park. This aerial view shows considerable development by 1979. (MAA.)

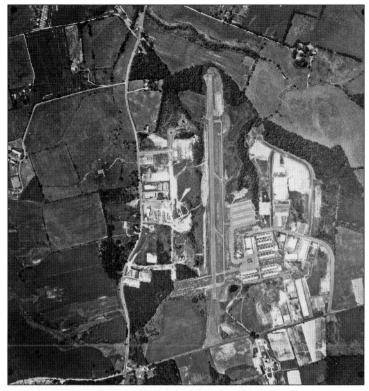

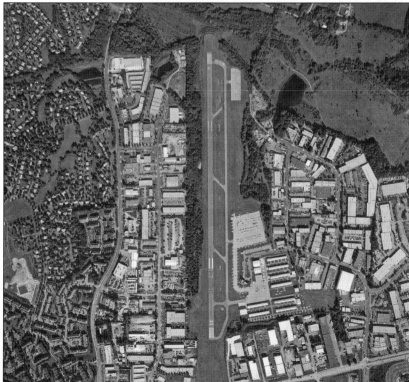

Even more development has taken place at Montgomery County Airpark by 2002. (MAA.)

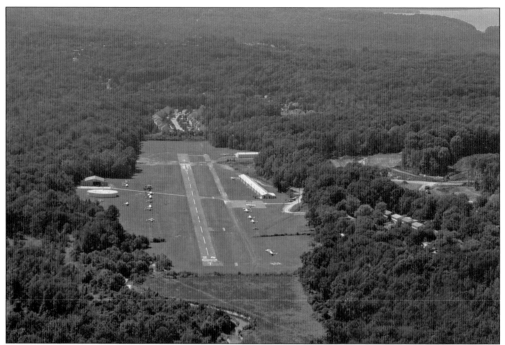

At the beginning of the 21st century, general aviation in Maryland (as elsewhere) was in crisis from the prices of fuel and airplanes, flying restrictions imposed since 9/11, and real estate development. Here suburban Featherstone Drive is built directly in the flight path of Runway 6-24 at Potomac Airfield in Prince George's County. (MAA.)

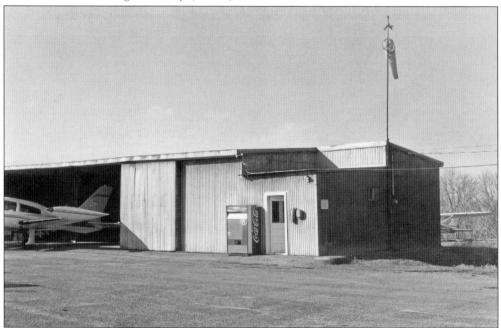

Maryland still has a number of small airfields equipped with "the basics," as seen at the Garrett County Airport near Oakland: a wind sock, an FBO's office, a telephone, and a soft-drink vending machine. (MAA.)

Four

NATIONAL DEFENSE

Aside from the Wright brothers' flight school at College Park, the oldest military aviation facility in Maryland is the Phillips Army Airfield at the Aberdeen Proving Ground, established in October 1917. The proving ground's overall mission was to evaluate the weapons used in World War I. (AOM.)

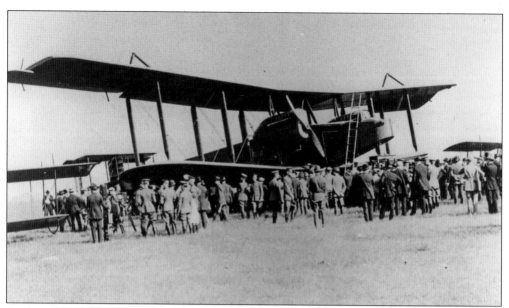

A giant British Handley-Page bomber is inspected by army officers at the Aberdeen Proving Ground in 1919. (AOM.)

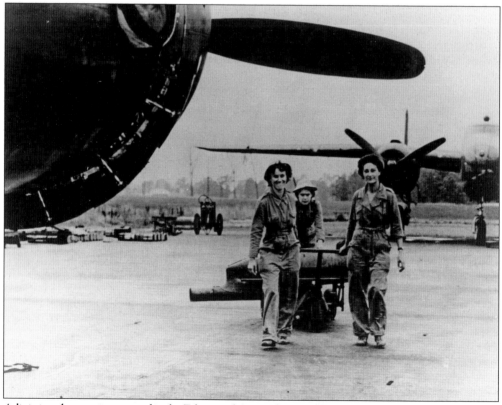

Adjoining the proving ground is the Edgewood Arsenal, originally specializing in chemical warfare. Here, at the arsenal's airfield in 1944, Women's Army Corps personnel wheel an underwing projector for FS smoke-screen gas past a parked B-25 bomber. (AOM.)

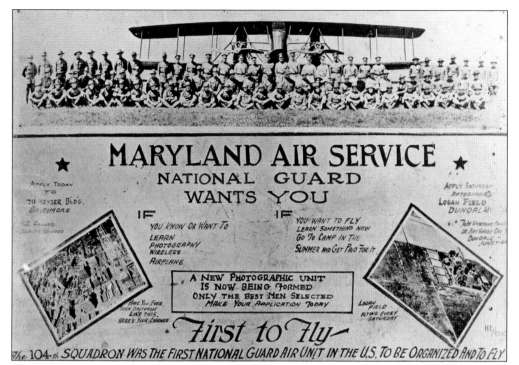

The Maryland Air National Guard was organized at Logan Field, Baltimore, in 1921. Designated the 1st (later 104th) Observer Squadron, this was one of the first air guard units in the nation. (AACHS.)

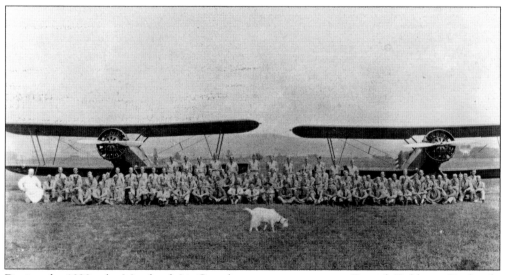

During the 1930s, the Maryland Air Guard went on maneuvers at Detrick Field near Frederick. Here the squadron poses with its mascot goat during the 1930s. South Mountain is visible in the background. (AACHS.)

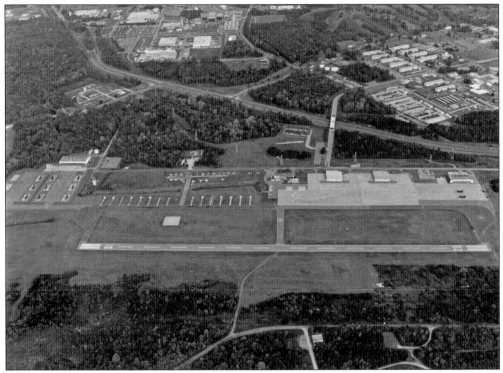

Tipton Airport in Anne Arundel County originally served Fort George G. Meade. It was named after Col. William B. Tipton, an army flier in both world wars and a former commander of the Maryland Air National Guard. The airport was converted to civilian use in 1999. (MAA.)

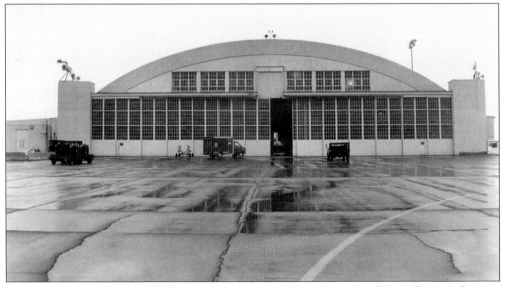

Andrews Air Force Base (AFB) occupies 4,300 acres at Camp Springs in Prince George's County. Constructed hastily in 1942–1943, it originally boasted four 5,400-foot runways and widely dispersed parking areas, with only three large hangars for aircraft maintenance. Besides housing the headquarters of the Continental Air Command, Andrews also provided for pilot training and the defense of Washington. (MHT.)

Andrews AFB came to supersede Bolling Field as the headquarters of the air force nearest the national capital. Building 1535 served as the first headquarters of the Strategic Air Command—in charge of U.S. nuclear forces from 1946 to 1948. (MHT.)

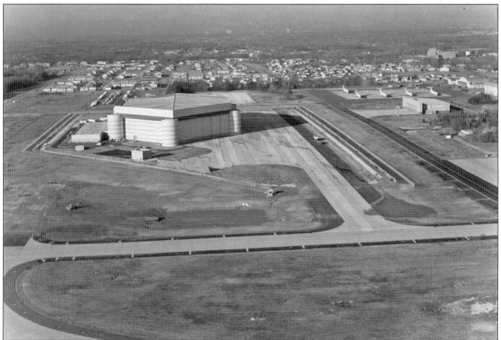

In the 1960s, the original runways were reconfigured to two parallel 9,000-foot runways. Andrews AFB came to be the aerial gateway to the United States for distinguished foreign visitors, and also the home airport of the American presidency. In 1988, the Air Force One Maintenance Complex was completed, a huge 151,000-square-foot hangar capable of servicing two national-command Boeing 747s at once. (Andrews AFB.)

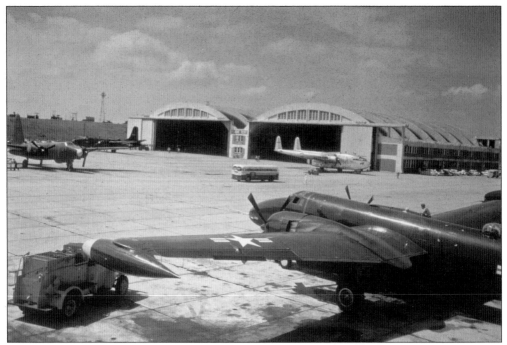

The navy also built a large air station near Washington during World War II, in rural St. Mary's County south of the capital. The Patuxent River Naval Air Station became the center of aircraft testing for the navy and the legendary home of "the right stuff." Here a pair of Lockheed P2V Neptunes share an apron with a Martin P5M Mercator and a Fairchild RQ4 Flying Boxcar. (Stan Piet.)

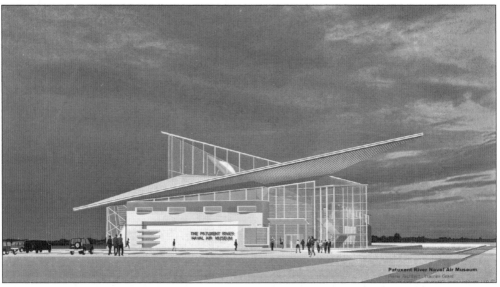

Patuxent River Naval Air Station opened in 1943 with three 10,000-foot runways. Three more 5,000-foot runways were constructed at Webster Field, two miles away at St. Inigoes. In 2009, construction will begin on a new Patuxent River Naval Air Museum at Lexington Park, intended to display the history and developing technology of naval aviation at this huge base. (PRNAM.)

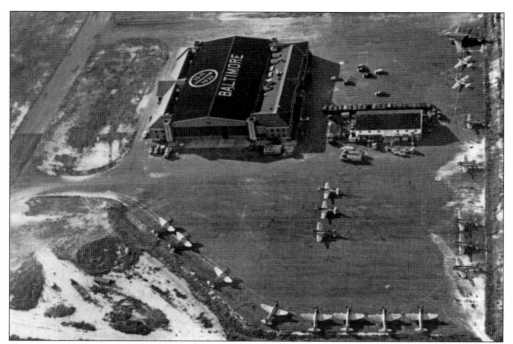

After World War II, the Maryland Air National Guard moved to the Baltimore Municipal Airport (later called Harbor Field). The guard's hangar and offices are seen here surrounded by P-47 Thunderbolt fighters. (MANG.)

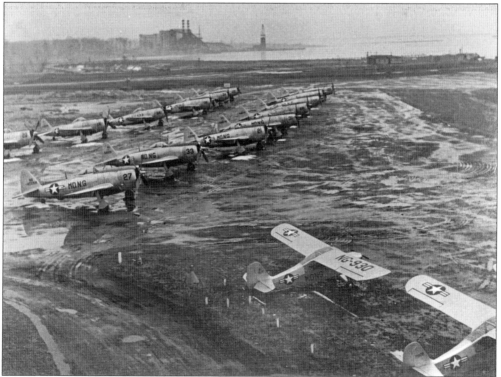

The Municipal Airport, built on harbor spoil, was apt to get soggy when it rained. (AACHS.)

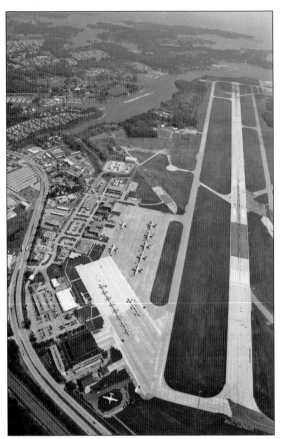

Beginning in 1956, the Maryland Air Guard moved its operation to Martin Airport, which was purchased by the state in 1975. The Warfield Air National Guard Base occupies 42 acres of the airport, which boasts a 7,000-foot runway. Martin State Airport is also home to general aviation activities, Maryland's emergency helicopter service, and the Glenn L. Martin Maryland Aviation Museum. (MANG.)

In 2008, the principal units of the 175th Wing, Maryland Air National Guard, are the 104th Fighter Squadron, flying A-10C Thunderbolt IIs, and the 135th Airlift Squadron, flying C-130J Hercules aircraft, shown flying over the Chesapeake Bay Bridge. Maryland Air Guard crews have been deployed to Bosnia and the Middle East. (MANG.)

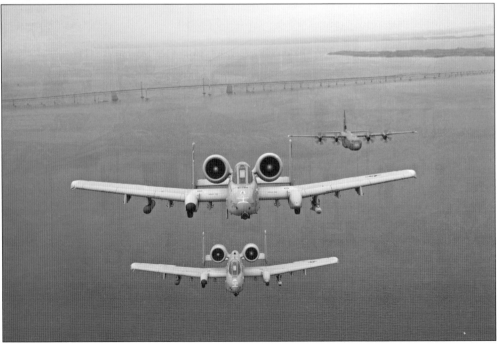

BIBLIOGRAPHY

Beatty, Ken. *The Cradle of Aviation: The National Aviation Field, College Park, Maryland.* Hagerstown, MD: Hagerstown Bookbinding and Printing, 1973.

Breihan, John R. "Between Munich and Pearl Harbor: The Glenn L. Martin Aircraft Company Gears up for War, 1938–1941." *Maryland Historical Magazine*, Vol. 88 (Winter 1993), pp. 389–419.

———. Breihan, John R. "Aero Acres: Glenn Martin Builds a Town." *Air & Space*, 14 (June/July 1999, 36–44.

———, Stan Piet, and Roger S. Mason. *Martin Aircraft, 1909–1960.* Santa Ana, CA: Narkiewicz/Thompson, 1995.

Harwood, William B. *Raise Heaven and Earth: The Story of Martin Marietta People and Their Pioneering Achievements.* New York: Simon and Schuster, 1993.

King, Jack L. *High Flight Beyond the Horizons: The Aviation Legend of Richard A. Henson.* Baltimore and Salisbury, MD: Jack L. King Associates and Richard A. Henson Foundation, 2002.

Lynd, William F. "The Army Flying School at College Park." *Maryland Historical Magazine*, Vol. 48 (1953), pp. 227–241.

Meyers, Kurtis. *Hagerstown during World War II, 1939–1945.* Hagerstown, MD: Hagerstown Aviation Museum, 2008.

Mitchell, Kent A. *Fairchild Aircraft, 1926–1987.* Santa Anna, CA: Narkiewicz/Thompson, 1997.

Piet, Stan, and Al Raithel. *Martin P6M Seamaster: The Story of the Most Advanced Seaplane Ever Produced.* Bel Air, MD: Martineer Press, 2001.

Poling, Bob. *Wings over Cumberland: An Aviation History.* Cumberland, MD: Commercial Press, 2002.

Preston, Edmund, Barry A. Lanman, and John R. Breihan. *Maryland Aloft: A Celebration of Aviators, Airfields, and Aerospace.* Annapolis: Maryland Historical Trust, 2003.

Rinehart, Theron K. *Yesterday, Today, Tomorrow: Fifty Years of Fairchild Aviation.* New York: Fairchild-Hiller Corporation, 1970.

Scott, John F. R. Jr. *Voyages into Airy Regions.* Annapolis: Ann Arundel County Historical Society and Fishergate Publishing Company, 1984.

Shank, Christopher. "Wings over Hagerstown: Experiencing the Second World War in Western Maryland." *Maryland Historical Magazine*, Vol. 88 (Winter 1993), pp. 444–461.

ACROSS AMERICA, PEOPLE ARE DISCOVERING
SOMETHING WONDERFUL. THEIR HERITAGE.

Arcadia Publishing is the leading local history publisher in the United States.
With more than 4,000 titles in print and hundreds of new titles released every
year, Arcadia has extensive specialized experience chronicling the history of
communities and celebrating America's hidden stories, bringing to life the people,
places, and events from the past. To discover the history of other communities
across the nation, please visit:

www.arcadiapublishing.com

Customized search tools allow you to find regional history books about the town
where you grew up, the cities where your friends and family live, the town where
your parents met, or even that retirement spot you've been dreaming about.